Donated in Memory of
Patricia Stankard
2006

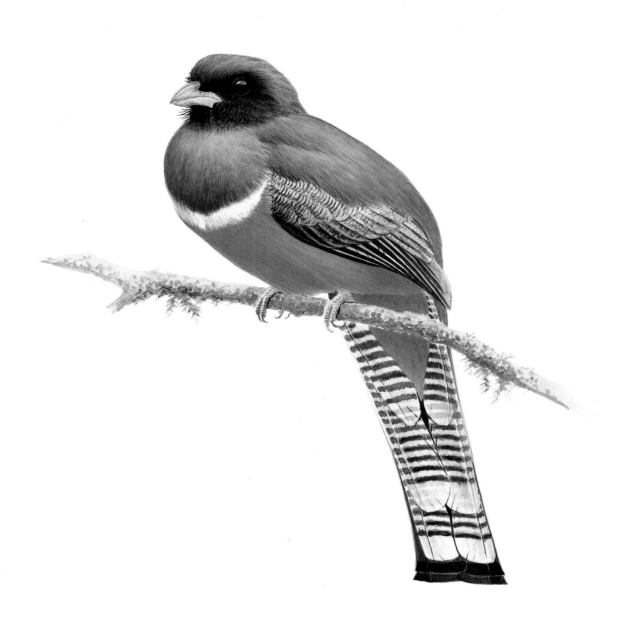

Painting
BIRDS

Susan Rayfield

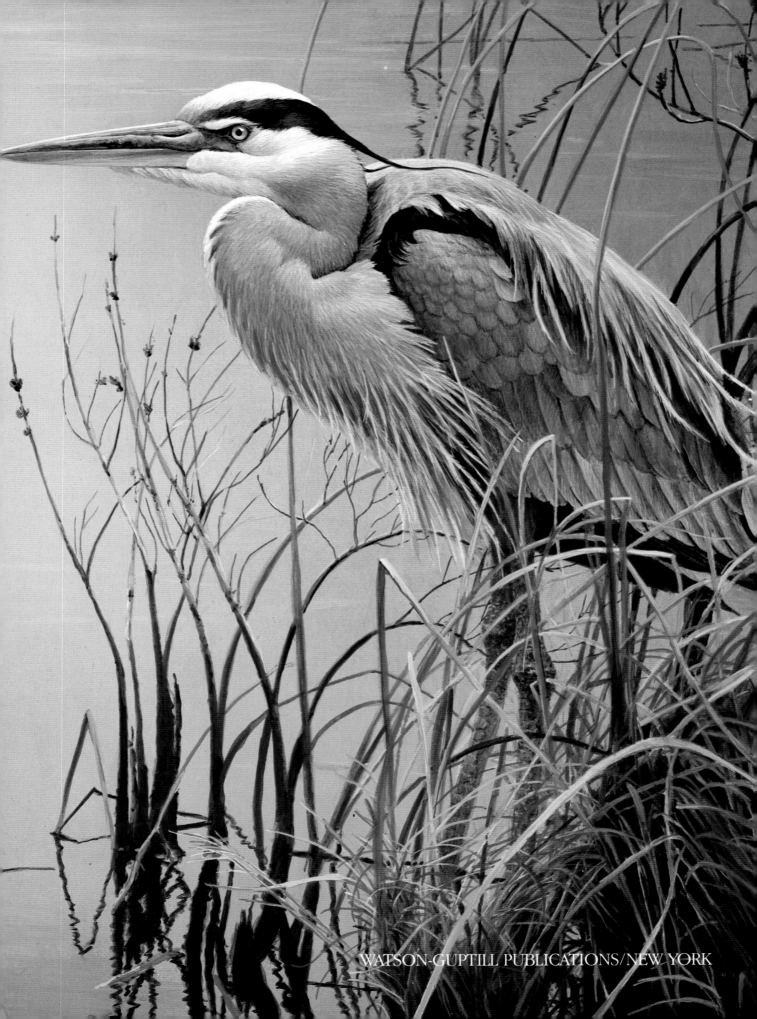

WATSON-GUPTILL PUBLICATIONS/NEW YORK

Painting on page 1:
John P. O'Neill, *Collared Trogan, Adult Male*,
1987, watercolor and acrylic, 15″ × 22″ (38.1 × 55.8 cm).

Painting on pages 2–3:
© 1978 Robert Bateman. *Great Blue Heron*.
Acrylic, 40″ × 30″ (101.6 × 76.2 cm).
Courtesy of the artist and Mill Pond Press, Inc., Fl 34292-3505.

These paintings appear on the following pages:

10–11: *European Robin and Hydrangeas* by Robert Bateman. 1985, acrylic,
10¾″ × 14⅜″ (27.3 × 36.5 cm). © 1985 Robert Bateman. Courtesy of the
artist and Mill Pond Press, Inc. Venice, Florida 34392-3505.

38–39: *Sound of Wings* by Manfred Schatz. 1972, oil, 48″ × 32″
(116.8 × 81.2 cm).

66–67: *Fallen Willow—Snowy Owl* by Robert Bateman. 1980, acrylic,
48″ × 29″ (121.9 × 73.6 cm). © 1980 Robert Bateman. Courtesy of the
artist and Mill Pond Press, Inc., Venice, Florida 34292-3505.

78–79: *Early Snow* by Guy Coheleach. 1982, oil, 15″ × 30″
(38.1 × 76.2 cm).

88–89: *Atlantic Puffins* by Robert Bateman. 1980, oil, 24″ × 11″
(60.9 × 27.9 cm). © 1980 Robert Bateman. Courtesy of the artist
and Mill Pond Press, Inc., Venice, Florida 34292-3505.

104–105: *Long-Tailed Sylph and Bomarea* by John P. O'Neill. 1987,
acrylic and gouache, 21″ × 18″ (53.3 × 45.7 cm).

116–117: *Bald Eagle* by Richard Casey. 1985, oil, 60″ × 40″
(152.4 × 101.6 cm).

Copyright © 1988 by Watson-Guptill Publications

First published 1988 in New York by Watson-Guptill Publications,
a division of Billboard Publications, Inc.,
1515 Broadway, New York, N.Y. 10036

Library of Congress Cataloging in Publication Data

Rayfield, Susan.
 Painting birds/by Susan Rayfield.
 p. cm.
 Includes index.
 ISBN 0-8230-3560-3 : $27.50
 1. Painting—Technique. 2. Birds in art. I. Title.
ND1380.RA35 1988
751.4—dc19

Distributed in the United Kingdom by Phaidon Press, Ltd., Littlegate
House, St. Ebbe's St., Oxford

Manufactured in Japan

1 2 3 4 5 6 7 8 9 10 / 93 92 91 90 89 88

This book is for Terence M. Shortt,
a great bird artist and a generous friend.

My thanks, above all, to the talented artists whose works appear in this book. Their generous contributions made it possible.

As always, it was a great pleasure to work with Bob Lewin, Mary Nygaard, and the rest of the staff at Mill Pond Press, Florida. Thanks also to William and Byron Webster, at Wild Wings in Minnesota, and Russ Fink, of the Russell A. Fink Gallery, Lorton, Virginia.

I am in debt to Carol Sinclair-Smith, assistant to Raymond Harris-Ching; to Patricia Armstrong, who is Robert Bateman's secretary; and to my neighbors, ornithologists Liz and Jan Pierson, for their advice about tropical bird art.

Paul Froiland, the editor of *Midwest Art*, graciously allowed me to use several comments by Manfred Schatz first published in that magazine. The artist's remarks were translated by Gabriele Reddin.

Thanks also to Tom Schoener and the Maine Department of Inland Fisheries and Wildlife, and to Oksana Adamowycz, of the Pagurian Limited, Toronto, Canada.

Finally, I deeply appreciate the efforts of the staff at Watson-Guptill Publications: senior editor Mary Suffudy, who encouraged the project and helped to shape it, Candace Raney, who edited the text, and Jay Anning, responsible for the design.

Contents

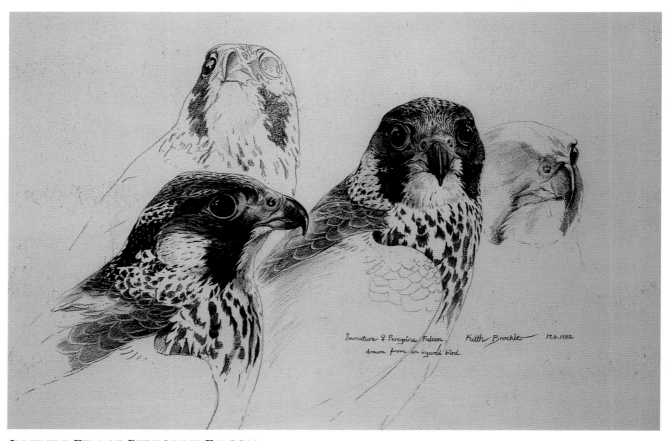

JUVENILE FEMALE PEREGRINE FALCON
*by Keith Brockie. 1982, watercolor and black colored pencil,
16" × 12" (40.6 × 30.4 cm).*

Introduction

I live in a cottage on a cove in Maine where light from the water shimmers on the ceiling and there is always a breeze from the bay. It's a far cry from New York City, where I spent most of my life.

Each spring I look forward to that day when the eider ducks parade their hatchlings along the edge of the shore for the first time—the fluffy brown chicks buoyant as corks. By summer the phoebe is flying back and forth to the porch again, and the song sparrow is raising her second brood in the Queen Anne's lace at the end of the garden. Sometimes we scratch at the soil side-by-side. I like to think she doesn't know I know where her nest is.

I watch through binoculars as kingfishers, herons, sandpipers, and terns go about the business of their lives just outside my door. And I listen as crows mob the resident great-horned owl by day, and the owl takes its revenge at dark.

Some of the best adventures in my life have had to do with birds—and some of the most unsettling. Such as the time I was nearly knocked off a cliff in Afghanistan by a lammergeier—the world's largest vulture. Or the time on Beetle Rock, in Sequoia National Park, California, when I was attacked by a giant angry bee—actually a displaying calliope hummingbird, one of the world's tiniest birds.

My passion for birds has been lifelong and consuming. It is not of the checklist variety. I prefer birding alone to birding in a crowd, and can spend more time with a backyard robin than with an exotically plumaged migrant. Sometimes I miss field marks, or forget the latest revised and updated name. It doesn't really interest me.

I enjoy the spirit and energy of birds. I'm intrigued by their combination of soft feathers, wiry feet, and bright eyes. I even love their smell—dry and faintly musty in the hand.

You don't have to be an artist to appreciate how a bird relates to a branch or a bunch of marsh grass, or notice how it blends into the landscape yet gives that landscape life. But if you are an artist, it helps.

It also helps to see that birds are not stuck on the top of a scene like a hard-edged decal but are softly enveloped and colored by atmosphere and light.

The wildlife artists featured in this book are among the finest in the world. They talk here about their own experiences with birds and how they capture the moment in pencil and paint. Styles and techniques may differ but all want the same result: to paint a picture that will make you feel the way they felt.

"There have been moments in my life that have surely changed me, and many times making a painting becomes an attempt to remember, to preserve and perfect memory itself," says Richard Casey. "When I'm painting I want only to conjure that time when my life was intersected by some magnificent wild creature: how the weather was, how the wind passed through fur or feather, and how I knew that in the next moment everything would dissolve and disappear. I want to communicate the fragility of those things in nature, which at times seem so persistent and powerful. It is all timeless yet it hangs by a thread."

Adds Raymond Harris-Ching: "That bird in front of you has to be the finest thing you've seen—it just has to be all you want to paint in the world at the time. Technical advice is not what the student needs. He or she may think that it is, but what is most valuable of all is to have the need and the urgency to get on with it. Just get on with it now—don't imagine you have time you can waste."

Listen to them. Learn from them. And enjoy their art.

—Susan Rayfield

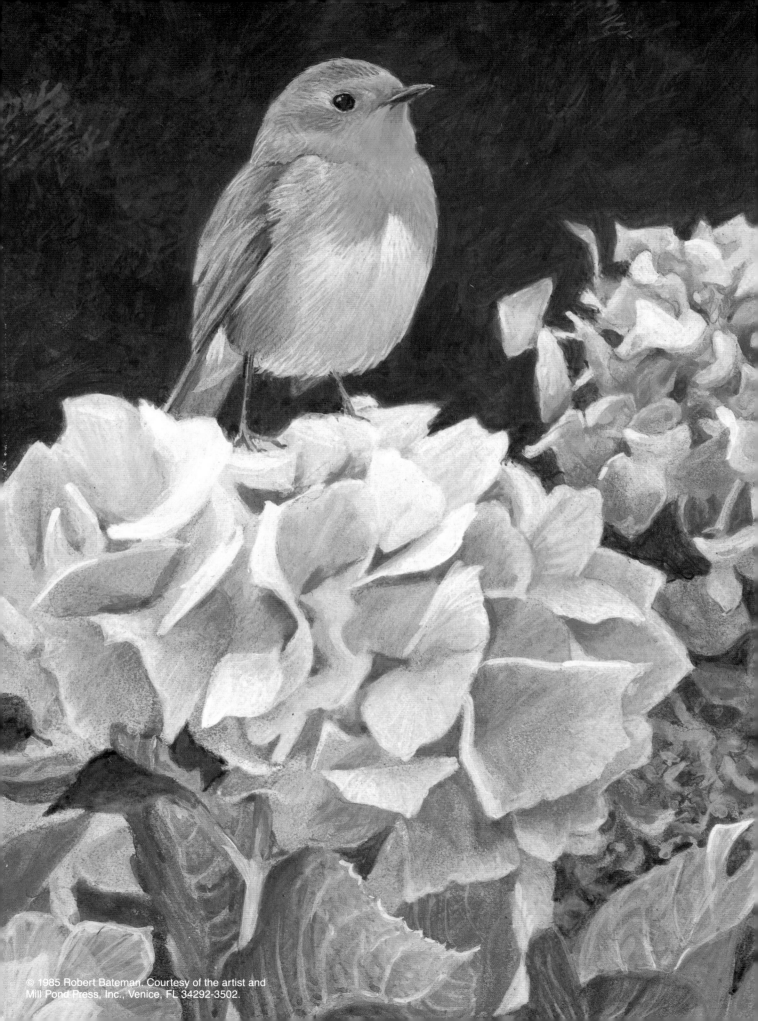

Birds of Field
and Garden

Robert Bateman — 1985 ©

Taking a Subtle Approach

Robert Bateman

Robert Bateman seeks the nuances of nature, preferring the understated to the obvious. For a Christmas theme he chose a trio of evening grosbeaks in a nontraditional setting: a misty, snowless day. "I really love that kind of weather," says Bateman. "It's more subtle than your average Christmas card winter with snow, red berries, and pine needles." Even the birch trees in the background are presented in an unusual way, with the emphasis on their seed tassels and bare filagree branches rather than the more familiar white bark.

The artist chose a subject right out of his own backyard. "When winter comes, I look forward to getting the bird feeder going," he says. "Evening grosbeaks either come in force or they don't come at all. The flocks are always squabbling." Here, two males bicker. But the more subdued female is, in a sense, the featured bird in this appreciation of grays and browns.

The males' poses are based on Plasticine sculptures that Bateman had shaped and painted for the project. He laid in the background first, then arranged the branches to accommodate the birds, adding and subtracting until he found a graceful, almost Oriental, rhythm. The grosbeaks are rendered with the artist's typical palette, which usually is restricted to yellow ochre, burnt umber, and ultramarine, in various proportions. For the brighter yellow areas on the males, Bateman used cadmium yellow medium and a little cadmium yellow pale, over an underpainting of white. The heads of the males are burnt umber, with some ultramarine added for shading. To capture the subtle purplish sheen on their crowns, the artist applied a thin semiopaque glaze, composed of cadmium red light mixed with ultramarine and a bit of white. Where the head color blends with the body color, yellow ochre was added. The black on the grosbeaks' wings and tails are a mixture of burnt umber and ultramarine.

Bateman wanted the picture to have a vertical feeling and so painted the background as a series of pale columns, slightly broken, with the birds in a staggered vertical arrangement in the center. The background was left deliberately mysterious. White areas at the bottom are intended as birch trunks; those at the top are meant to be patches of sky. Each metamorphoses into the other at the crossover area in the middle of the work.

One of Bateman's most common techniques is to kill an entire painting with gray washes and then go up and down the tonal scale selectively. "I bring the whole painting down so I'm using octaves in the middle tone," he explains. "Then I put in just five or so high notes and about three low notes." Often, at the very end, he will add wide tonal washes to lighten the entire bottom or darken the top of a painting. A favorite brush for the process is Pro Arte, size 5, an artificial sable, or a round hog's hair Grumbacher, size 6.

Here, when most of the work had been completed, Bateman killed the whites with a dirty greenish mixture of ultramarine and yellow ochre, then snapped them up to clean white again. "It's like quieting an orchestra so you can hear the flutes," he says. "I need to quiet the painting down to make the whites speak." He did the same for the darks. As a final touch, he emphasized the black cracks in the feathers, applied a dash of yellow here and there, and added a highlight to the eyes.

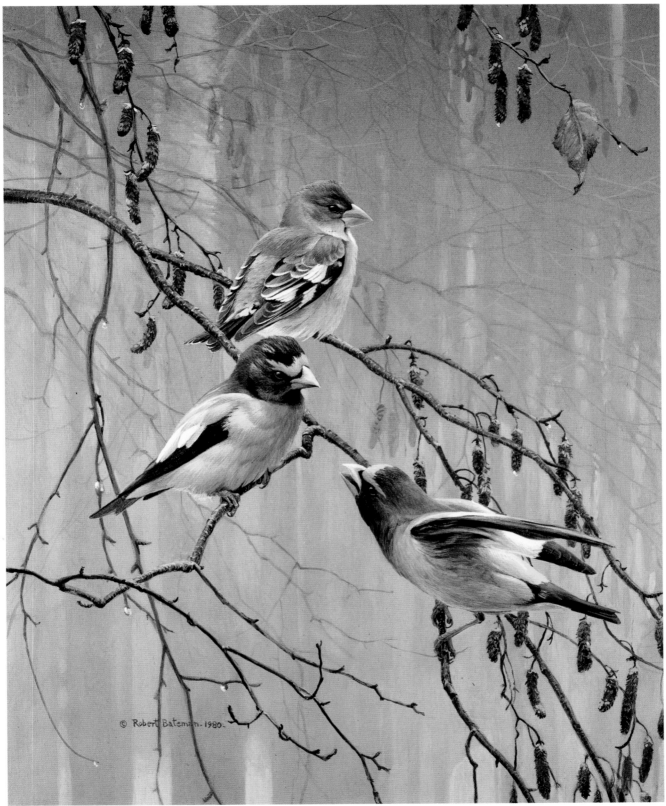

EVENING GROSBEAKS
1980, acrylic, 16" × 21" (40.6 × 53.3 cm).

Conveying a Bird's Character

Lawrence B. McQueen

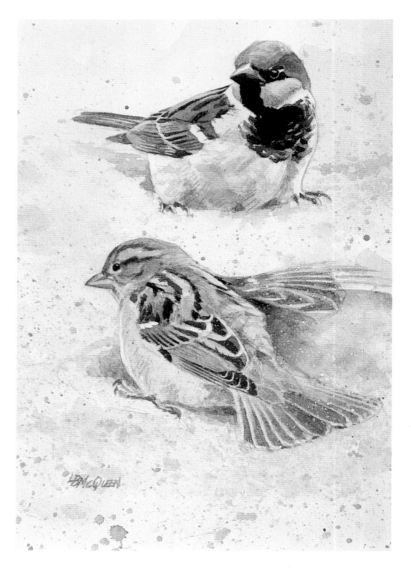

HOUSE SPARROW
*1987, watercolor, 8" × 11"
(20.3 × 27.9 cm).*

The aggressive stance and blueness of a jay, the upright posture of a robin—each bird has its own unique combination of traits that help to identify it. The portraits on these pages are part of a series of bird identification flash cards, painted for the Cornell Laboratory of Ornithology in Ithaca, New York. Each presents a common North American bird in characteristic pose or behavior. Since the cards are small in their final form, artist Larry McQueen maximized the size of the birds within the format. He also attempted to keep them loosely painted, knowing they would tighten up somewhat when reduced in size.

Here, McQueen shows a pair of house sparrows taking a dust bath: the spread-foot stance of the male giving him the cocky look typical of the species. The highlight on its

distinctive bill, which is slightly broader and more rounded across the top surface than the bills of native American sparrows, points up another identifying mark.

McQueen started the painting with a wash of yellow ochre across the background and the birds, except for the whitish parts of the male. While the surface was still wet, he added a few sprinkles of Payne's gray for textural and color variation. At this point, the artist put some rhythm in the female sparrow's wing by adding touches of crimson in a regular pattern beneath it. He wanted to keep the flapping wing underdeveloped, relying on the repetitious lines of the flight feathers to enhance the impression of motion. Next, he added the shadows in indigo. Variations in plumage tone are made up of yellow ochre, raw sienna, and burnt sienna. Both the gray and the black on the male's

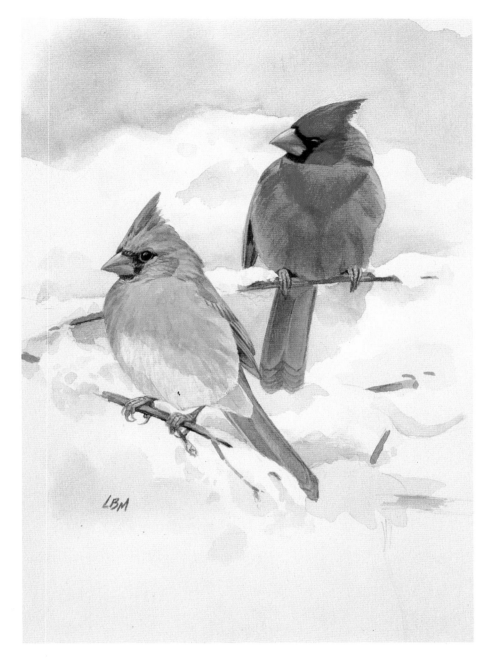

NORTHERN CARDINAL
*1987, watercolor, 8" × 11"
(20.3 × 27.9 cm).*

head is Winsor & Newton's neutral tint mixed with indigo, in different intensities. McQueen added the effect of dust and motion by snapping a stiff oil brush with his thumb, spattering the same colors that were used in the painting with both transparent and opaque watercolor.

Cardinals have a different set of identifying traits. These brightly colored birds are bold and reserved at the same time, tending to sit quietly in the open. "The bill is full but looks even larger by its bright color and the bird's smallish head," notes McQueen. "Painting the head too large will only make the body look small." Cardinals also have short wings and an expressive tail.

The male cardinal is painted almost entirely in Winsor red, shading included. "I just use a more intense red for the modeling rather than some other color, because the

only way to keep red bright is by using it straight out of the tube without adding anything to it," explains McQueen. Sometimes he will add texture in a duller red, such as alizarin crimson, or by mixing in neutral tint, as seen on the cardinal's tail.

The female cardinal is one of McQueen's favorite birds. "Look closely and you will see a blend of some of the softest, warmest colors imaginable," he says. "The misty pink on the undersurface of her tail is like a delicate, iridescent rouge." He rendered this one primarily in yellow ochre, warmed with raw sienna, and grayed and softened with neutral tint.

The black around the bill of both birds is pure neutral tint, darkened by successive layers. Their feathers are puffed out on a cold winter day.

Mastering Bird Anatomy
Lawrence B. McQueen

SCRUB JAY
1987, watercolor, 11" × 9" (27.9 × 22.8 cm).

"Almost all jays have an audacious personality," says Larry McQueen, "and the scrub jay can be among the most boisterous." Here, its open beak, alert look, and spread-legged stance express the bird's assertive spirit. The jay illustrates some of the basics of bird posture and anatomy, important for any wildlife artist to master.

When, as shown here, a bird is portrayed on a vertical branch with its feet at an angle to the eye, the effect is of being off balance, which conveys energy and action. On the other hand, to balance a bird, at least one foot directly beneath the eye tends to balance a bird. Long ago, McQueen learned from wildlife artist Don Eckelberry that birds do not cling to branches with a "death grip," but actually perch rather loosely. The way they grip a branch or stem can vary considerably. When songbirds perch on vertical stems, the foot that is down often has two toes together on the downside, for a brace, with the third toe upward, as a hook.

For McQueen, the placing of the eyes is as important as the placing of the feet. Many artists set the eye too high in the face, he notes, or too far from the corner of the mouth. Also, birds' eyes are not round but are variable in shape. Most tend to flatten out at the top. He advises drawing the eye's outer edge as a hard line, and "as black as you can make it" to visually separate it from the surrounding tissue. Putting in a hard white highlight will often make it seem as though the bird is looking at the observer. McQueen, however, prefers a softer reflection, with the highlight a dull tone, just a little lighter than black, covering more of the eye's surface. "It's something you see a lot with birds in soft white light, like forest birds," he says. Often, there is no highlight.

Knowing how to paint a closed wing requires an understanding of the structure and use of the wing when it is open. The length of the outer wing feathers, the primaries, varies according to the type of bird. Those that spend much of their time flying for food, or migrating long distances, such as swallows and terns, have wings so long they may actually overlap the tail when folded. On the other hand, many songbirds, which move through vegetation, require shorter, more rounded wing tips.

In an open wing the flight feathers, or primaries, radiate out from a point on the "hand and wrist" of the bird. The next series of feathers in, called the secondaries, do not fan out but rather line up in a row. When the wing is closed, its shape is determined by how the secondaries "pile up," and the extent to which they overlap the primaries. Often the tail is drawn from a point too low or too high on the bird's body, notes McQueen. Its angle should indicate its point of origin, radiating from the center of the rump just below the back. "There are no tricks of the trade to understanding these details," he says, "other than by studying the birds themselves."

McQueen painted the scrub jay's plumage in shades of ultramarine blue. Its breast is a pale wash of Winsor & Newton's neutral tint warmed with some yellow ochre. Layers of neutral tint make up the black on its face; its white throat and eyebrows are raw paper.

As shown in McQueen's sketch of a jay, when a bird is looking down, its head is slightly cocked and the eye seems low in the face and flattened at the top. From this angle, there is usually no reflection in the eye.

Letting the Composition Evolve Naturally

Lawrence B. McQueen

What is left out of a painting can be just as important as what is put in. Here, the space between the branches and robin become an integral part of the work. At first, artist Larry McQueen had apples scattered throughout the composition, but their color competed with the bird. Eventually, he decided on a triangular arrangement, with a single robin set away from the fruit. "I like a composition that is somewhat open and unresolved, rather than one so perfectly balanced as to be stagnant," says McQueen. "This is much more difficult to do than it may seem, as it's natural to be orderly. Ideally, I want control of the painting so that it will not look controlled."

Frost Robin was painted in January, soon after McQueen had returned from a long trip abroad. The trees and bushes around his studio in Oregon were filled with fat robins, feeding on winter fruit. "It was a delight to see them," says the artist. "I felt I was being welcomed home." To capture the sense of a frosty, foggy morning, the artist kept the values low-key.

The robin's breast was first washed with yellow ochre, then overlaid with more washes of burnt sienna, vermilion, and more ochre. Its gray parts are Winsor & New-ton neutral tint, warmed with sepia and some burnt sienna. "I love to work with the quiet muted colors of sparrows, plumages of female birds, and of this robin in winter," says McQueen. "Although less conspicuous, such birds are no less challenging to paint, as the colors are rarely pure and must be achieved by overlays and careful blends."

McQueen used a graphite tone, almost like a pigment, in some areas of the branches and part of the background at left, then applied overwashes of indigo, selectively building the intensity. Areas of frost and snow are bare paper, with details rendered in grays and manganese blue. Some opaque white was used around the frosty apples, which are a combination of warm colors, including Winsor red. The bruised parts are indigo blue warmed with umber.

At first, McQueen thought the placement of the apples at the top of the composition looked simplistic, and that the fruit and the robin were overpainted. "But the painting has taken on a life of its own, which is very charming," says the artist. "It now is a favored piece of mine."

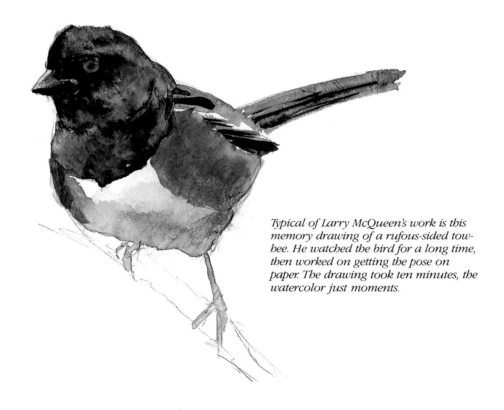

Typical of Larry McQueen's work is this memory drawing of a rufous-sided towhee. He watched the bird for a long time, then worked on getting the pose on paper. The drawing took ten minutes, the watercolor just moments.

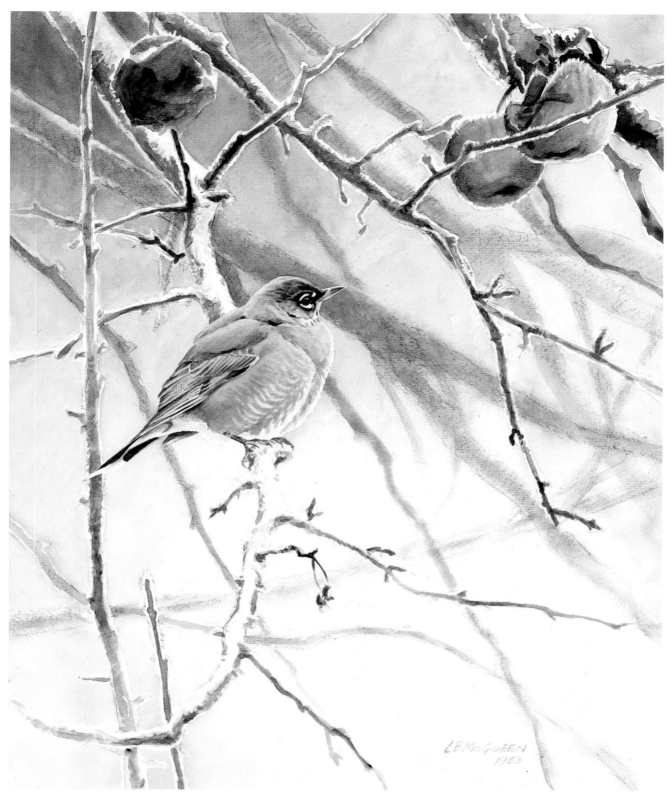

FROST ROBIN
1983, watercolor, 15" × 19" (38 × 48.2 cm).

Using Neutral Tint to Make Black

Lawrence B. McQueen

Depending on the way it is handled, the color black can convey velvety depth or a glossy sheen. The rich dark hue of the displaying male red-winged blackbird was achieved by covering the bird's entire surface with black, only minimally indicating form with highlights. To get the shiny blacks of the birds in flight, artist Larry McQueen worked in reverse—covering the birds mostly with gray, meant as highlights, and indicating form sparingly, in black.

In *Red-Winged Blackbird*, the black was built up with repeated applications of neutral tint mixed with indigo. Neutral tint, one of McQueen's favorite working pigments, is made by Winsor & Newton, designed as an additive to make hues duller without changing the color. McQueen uses it alone, however, as a gray wash to soften plumage, and when built up in layers, as a rich black. Any intense color added to it, such as alizarin crimson, Prussian or phthalo blue, will further deepen the black.

Black highlights can be accomplished in three ways: lifted out by wetting, blotting, or erasing; transparently built up and left lighter; or adding on with opaque white or an opaque light color, as done here. Detail was kept to a minimum and highlights used only to indicate the bird's swollen neck and raised shoulder feathers. The tension and energy of the displaying male is enhanced by its foreshortened stance. The red patches provide maximum contrast and tilt toward the female; and the spread tail expands the black surface even more. The shadow cast by the male on the cattail helps define the form of both and establishes the relationship between them.

In the painting of blackbirds mobbing a crow, the background wash is cobalt blue, also the base color for the birds' sheen. Neutral tint was added for the birds, after the background had dried. For a change of tone, burnt sienna and alizarin crimson were then selectively applied. The blackbirds' red epaulets, masked during the surrounding darker washes, are Winsor red and Liquitex Hansa yellow. "Liquitex Hansa yellow is about the purest, brightest yellow on the market," says McQueen, "other brands of this color tend to be greenish or a lemon yellow." The crow's strong flight feathers dominate the design, while its dangling feet emphasize the disturbance.

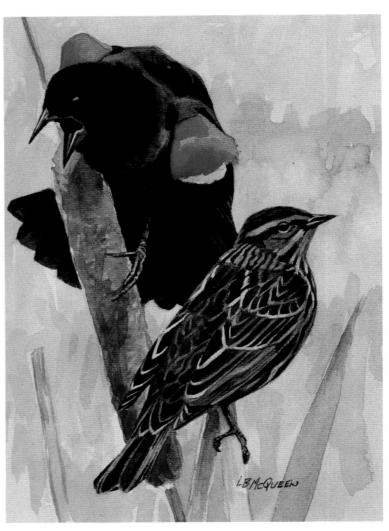

RED-WINGED BLACKBIRD
1987, watercolor, 9" × 11" (22.8 × 27.9 cm).

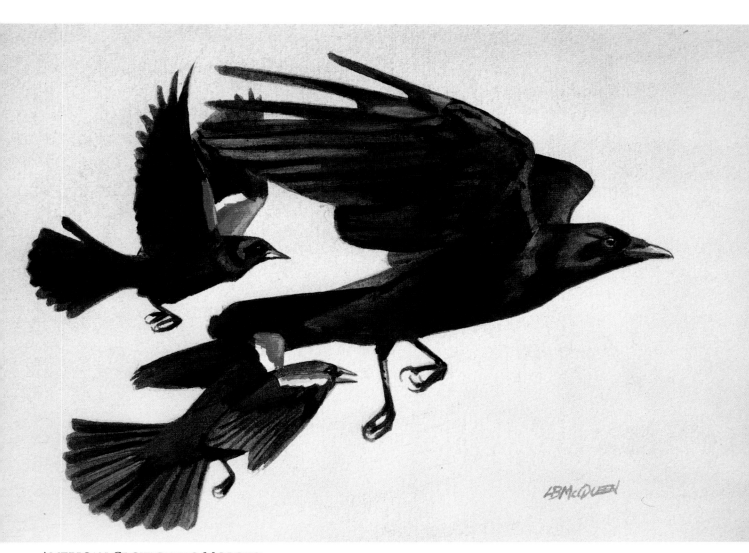

AMERICAN CROW BEING MOBBED
BY RED-WINGED BLACKBIRDS
1987, watercolor, 11" × 9" (22.8 × 27.9 cm).

Capturing the Spirit of Chickadees

Lawrence B. McQueen

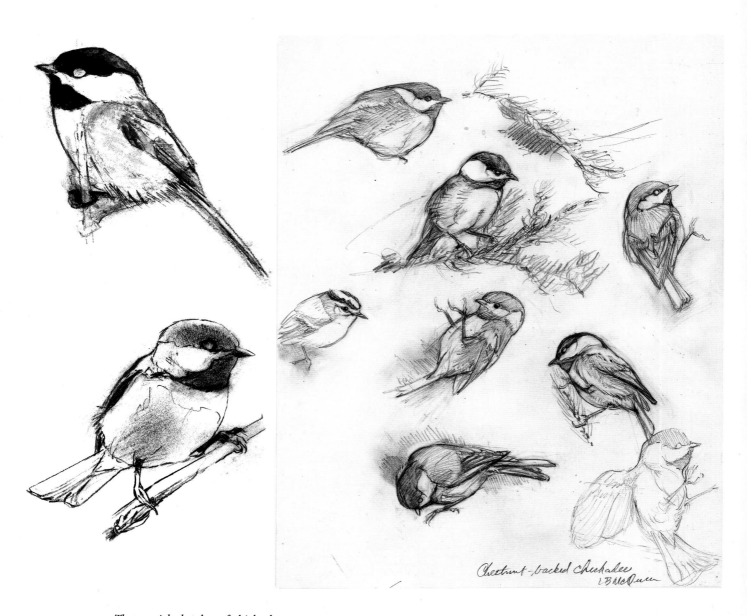

Chestnut-backed Chickadee
L B McQueen

These quick sketches of chickadees were done from life and the artist's recollections. McQueen works on form and posture first, to get the feeling of the whole bird, then concentrates on the proportion of its head, particularly the relationship between beak and eye. Says McQueen: "If you get the expression of the living bird—really make it look alive—everything else will follow."

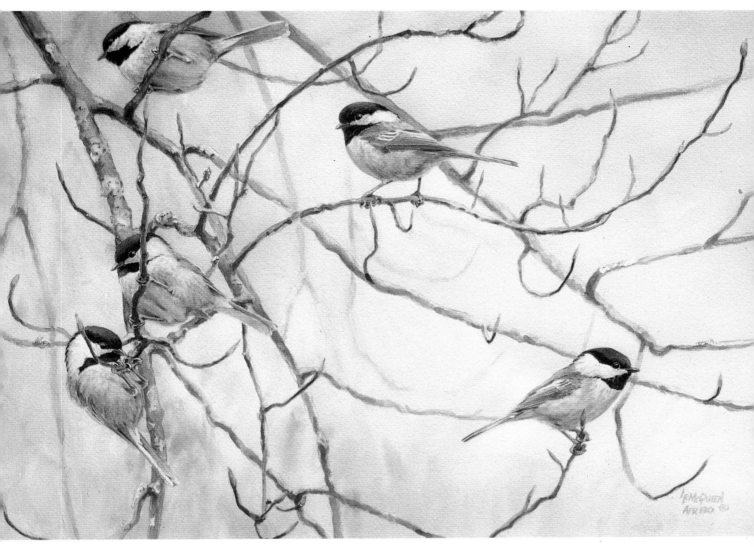

BLACK-CAPPED CHICKADEES
1980, watercolor, 19.5" × 13.5" (49.4 × 34.2 cm).

Chickadees are popular wildlife subjects yet few paintings of them are successful. In life, the birds are tiny bundles of energy, quick and light. In artwork, however, they often look wooden and clumsy. Larry McQueen believes the major error many artists make may be in overpainting them. Too much detail stops action and results in a hard-edged look. "All the important features can be achieved by implication and destroyed by excessive detail," he notes.

Getting the proportions correct also is important. Chickadees have large heads, which makes their bodies seem smaller by comparison. Their tails are long and slim. And since they often hang by their feet, counterweighting their bodies among the branches to get at food, their feet must be strong, achieved by strong, definite drawing.

The poses were worked up with the aid of photographs, sketches from life and study skins. Avoiding only the whitest area of the birds, McQueen started with an initial wash of Payne's gray, deepened with indigo and neutral tint for the black parts, and modified with burnt sienna and yellow ochre on their flanks. Cerulean blue, indigo, and burnt sienna were used for the body shadows.

The artist wished to portray the independent spirit and energy of the tiny birds, and so posed each chickadee separately. "They are not interacting, they are simply together," he says. "This seems to be a trait of winter flocks." The birds' small round forms are randomly placed, juxtaposed with open areas and the linear rhythm of the branches. The artist believes it's important not to have things too repetitive, like a steady beat, but rather opposing and contrasting, with interesting shapes and sizes. To convey depth, he has some branches coming toward the viewer, their shapes strengthened by underlying shadows. The background is diffused by fog. Those things seen clearly are close at hand, which also may suggest the trusting nature of the birds.

Painting Birds Life-Size
Raymond Harris-Ching

Painting birds life-size has been a long-standing tradition among wildlife artists, and many students find the discipline of such accuracy important. Here, one of the world's most familiar—and often most disdained—bird, the starling, is portrayed actual size on a white background with a single, carefully selected branch. Nothing else distracts the viewer. "It is clearly understood that the bird is not five or ten feet back into the painting but rather is placed directly there—just behind the glass of the frame," explains the artist, Raymond Harris-Ching. To get exact measurements, he held the dead bird to the paper and marked off the key points—bill, wings, and tip of tail.

The starling was posed with an arrangement of wires and struts, much the way pioneer bird artist John James Audubon set up specimens for his work years ago. Of necessity, Harris-Ching had to finish the painting quickly, before decomposition set in. Despite such limitations, he finds working directly from fresh specimens well worth the effort: The paintings have a vitality not always apparent in studies made more slowly, from museum skins.

Many artists have a tendency to paint feathers hard, laying them on like scales. Harris-Ching, however, conveys the intrinsic softness of birds, painting their feathers with loft that takes the viewer's eye deep into the plumage. "The only thing that stimulates me to paint is when I've got the object right in front of me," he says. "If I can't feel it with my hands, and even my eyes, I can't translate it. If my eyes, and even my hands can go around it, I can sense its depth and softness."

To emphasize its decorative throat hackles, the starling is shown in a characteristically aggressive calling stance. Every feather has a white dot on it, found only on the winter plumage, and is casting its own shadow. "If you look into each long feather and you carefully draw each one, you're painting something as gorgeous as the twelve-wired bird of paradise," says Harris-Ching. The leafless branches reinforce the fact that only in winter does the starling look quite so exotic.

STARLING: WINTER BIRD
1973, watercolor, 20" × 28" (50.8 × 71.1 cm).

Detail shows the starling the same size it was painted, which is exactly life-size.

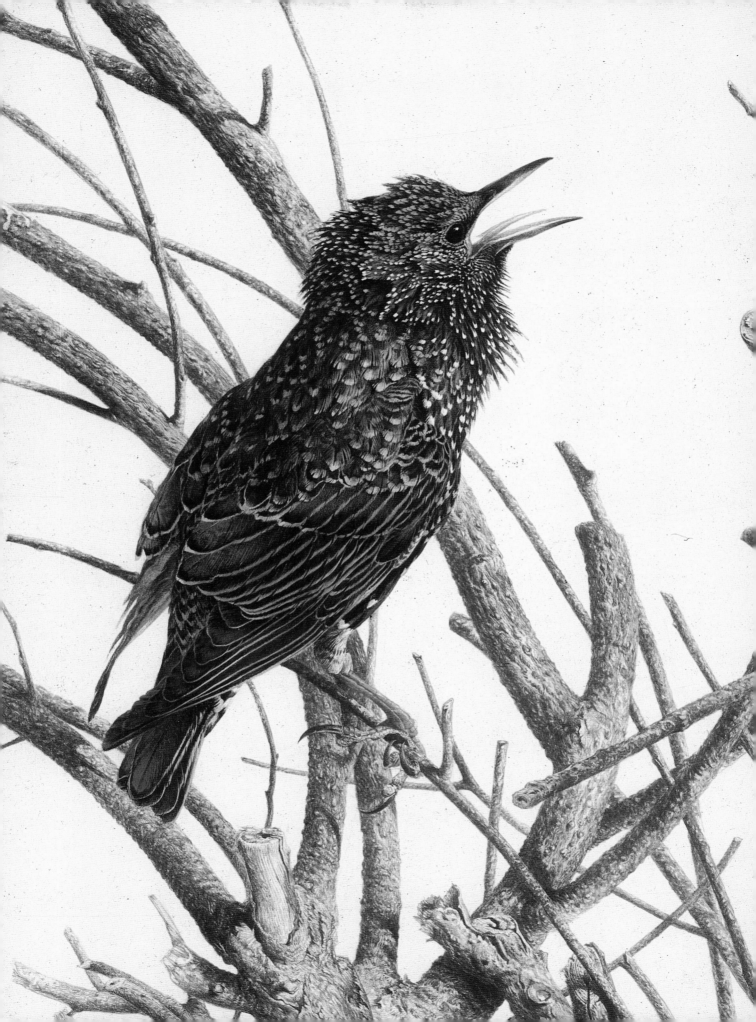

Maintaining Color Intensity

Robert Bateman

Robert Bateman challenged himself with *May Maple and Scarlet Tanager* and found the painting to be one of the more difficult he has ever done. To fully capture the bird's fluorescent glow, he realized he would have to paint it against a dark background, but the picture became too somber. When he lightened it with thin white washes, the tanager lost color and the contrast disappeared. Bateman had chosen an interesting position for the tanager, with its head turned, but the pose also gave him trouble: the bird looked too chunky. Finally, disliking the combination of red and green, the artist was determined to avoid placing the bird next to leaves but couldn't think how else to convey the light feeling of spring. "The painting was fraught with problems," he says. "I think it turned out fine, but it was a struggle."

In the end, Bateman decided to perch the bird among a sugar maple's diminutive spring flowers, which the artist finds more beautiful than orchids (although far more subtle and usually overlooked). "I felt that the long dangling stamens fit with the opulent look of the tanager," he explains. Their greenish-yellow color is made up of cadmium yellow pale, with a bit of phthalo blue. New leaves, still wrinkled, are beginning to unfold beside them.

The scarlet tanager, a fiery orange-red, seems lit from within, an effect hard to achieve with pigment. Where Bateman wanted the bird to glow, he laid down white first, then yellow overall, followed by washes of cadmium red mixed with a bit of yellow. "I had to do very thin washes, the way the Renaissance artists did," he says. "I wanted an effect something like a stained glass window, with a little bit of light coming through the yellow and the red." The tanager's black wings and tail are rendered in Payne's gray, with varying amounts of raw umber—a color increasingly present in the artist's palette for making a good black or gray.

The background recedes into mist, which the artist created by sponging on a series of thin vertical washes, containing a bit of opaque color. Greenish-yellow and gray whips of color indicate the branches of middle-distance trees; a break in the screen at the upper left conveys a distance. The low, horizontal composition has a Japanese influence.

MAY MAPLE AND SCARLET TANAGER
1984, acrylic, 16" × 9" (40 × 22.8 cm).

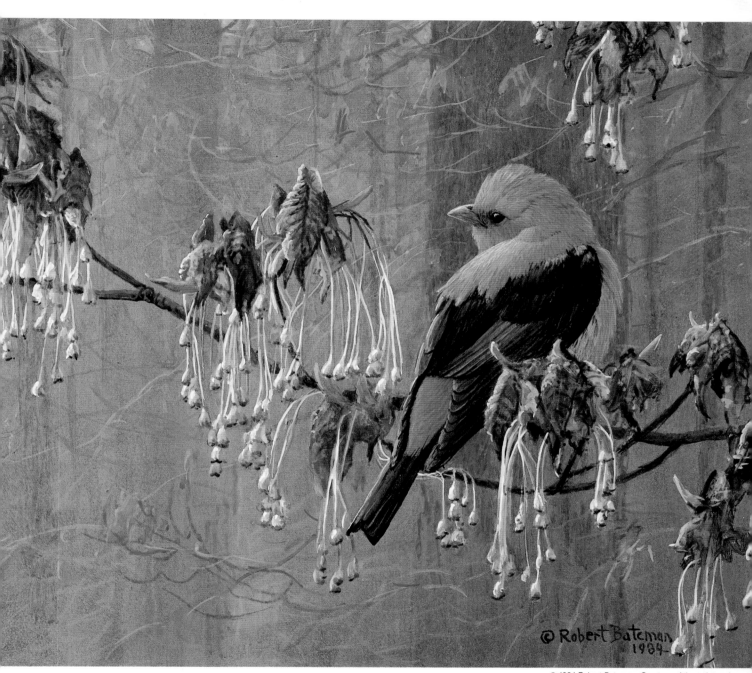

Painting Woodpeckers
Robert Bateman

Woodpeckers make interesting subjects but the results can prove disappointing. Too often, the bird looks stuck on a tree, like an afterthought. In this portrait of a pileated woodpecker, Robert Bateman has positioned the bird somewhat inside the trunk's outer edge, making it an integral part of the picture. The bird's cast shadow on the bark helps to further establish the connection. "Artists who paint woodpeckers are in the same boat—woodpeckers *are* stuck on," says Bateman. "They are in contact at just three points: the tail and two feet." Here, Bateman established the three contact points carefully, relating the bird organically to the bumps and hollows of the tree. Its claws hook solidly around a piece of bark and its tail is not just spiked stiffly into the trunk but bends naturally, to act as a brace.

Bateman painted the beech tree as full of crevices and insect holes as the woodpecker might see it, "with everything in focus and full of potential interest and promise." Working from photographs, he approached the trunk like a sculptor—interested in its form and volume. He saw a landscape of cliffs and valleys in the complex textures of its elephant-skin bark. The artist started with a big brush and bold dark strokes, followed by some light marks, then filled the spaces in between with a smaller brush, building up surface textures slowly and carefully.

Bateman left more room above the woodpecker than below it, allowing space for the bird to hitch upward. The bird's vertical posture between the two horizontal bands on the trunk set up a visual tension. To avoid having the trunk itself look "stuck on" the light background, the artist brought some white into the tree itself, in the form of patches of snow in a few of the crevices.

Of the bird itself, he says "I find the facial arrangement of the pileated woodpecker very satisfying. These birds seem cocky and aggressive. When I was working on this painting I was thinking of samurai warriors and I gave the feathers an almost armorlike quality."

PILEATED WOODPECKER ON BEECH TREE
1977, acrylic, 24" × 36" (60.9 × 91.4 cm).

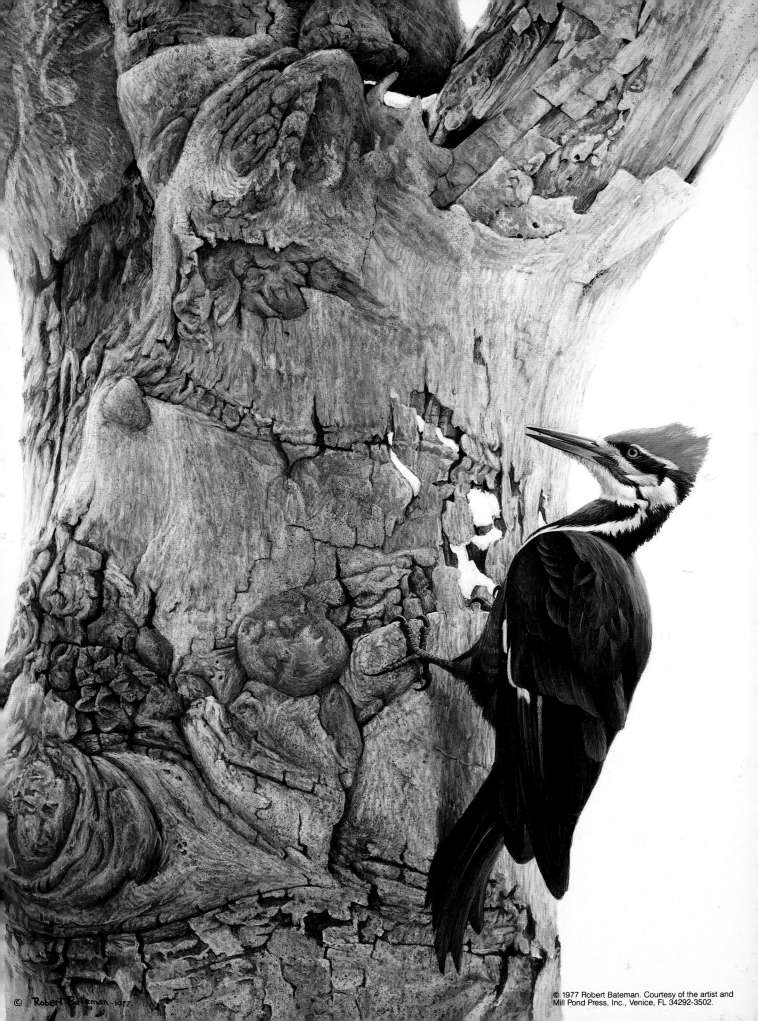

Capturing the Rhythms and Forms of a Meadow

Robert Bateman

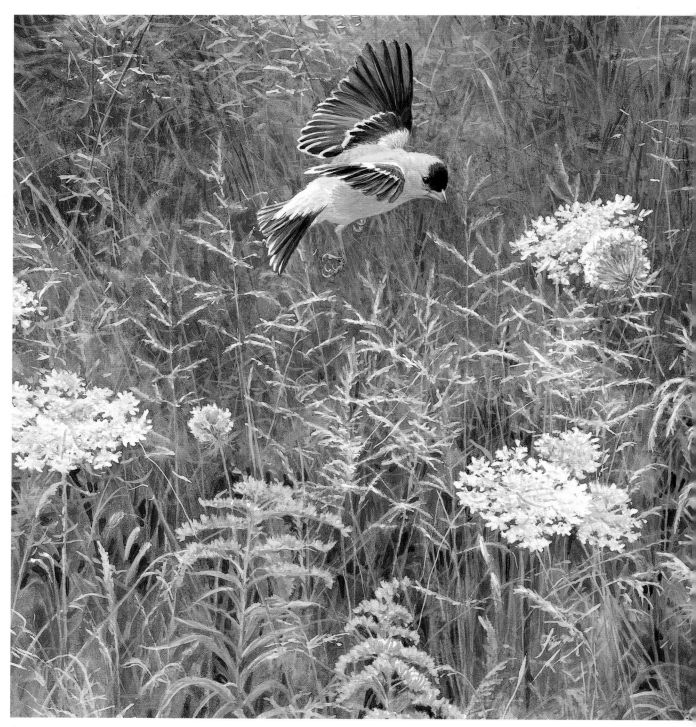

QUEEN ANNE'S LACE AND AMERICAN GOLDFINCH
1982, acrylic, 16" × 11½" (40.6 × 29.1 cm).

© 1982 Robert Bateman. Courtesy of the artist and Mill Pond Press, Inc., Venice, FL 34292-3502.

A painting with a regal title, *Queen Anne's Lace and American Goldfinch*, is dedicated to the memory of Princess Grace of Monaco. The work is also an homage to Canadian artist Robert Bateman's own meadow. "It's a hunk of the world that is basically considered to be weeds, overlooked and not respected by most people," says the artist. "They just walk over it and walk through it and don't notice it." The flowers—Queen Anne's lace and goldenrod—signal the yellow opulence of late summer.

Bateman deliberately kept the composition open; if he hadn't painted the bird, there would be no center of interest. The flowers are placed seemingly at random, with several at the edge even half cropped out of the frame. "I wanted it to look like a slice of life and not like an arrangement," the artist explains. "That's why I was quite careful to contrive it to look uncontrived." After he had positioned the flowers, Bateman established the rhythms and forms of the meadow with a mixture of opaque white, yellow ochre, using a big brush. He built up the grasses gradually, avoiding detail until the very end. "I almost get a dancing feeling as I paint because I want a dancing feeling in the picture, a series of painted rhythms akin to music," says the artist. The tops of the grasses are like delicate passages. But even though the scene may suggest great detail, it is not a detailed painting—only a few of the plants are clearly delineated.

Many artists paint grass like a screen, but here there are grasses in between the grasses. "You have to think of the whole three-dimensional space, its depth," notes Bateman. "The higher you look across a meadow toward the horizon, the less you see into it. But look down at your feet, and you look right into it." *Queen Anne's Lace and American Goldfinch* is structured just that way. The bottom of the picture, at the viewer's feet as it were, has more contrast, more openings, and stronger grass color than the top of the painting, where the grasses are farther away. Toward the end, Bateman went in and put little dark shadowy cracks between the grass blades, then opaqued everything out to blend.

The goldfinch hovers above a column of gold, an effect the artist wanted the viewer to be unconsciously aware of. Everything directly beneath the bird is underpainted, to make the connection with the goldenrod even stronger. To achieve the bird's sense of buoyancy, Bateman toned down the meadow behind it with semiopaque washes. Overlapping feathers in the translucent wing add to the light and airy feeling. The goldfinch's plumage is cadmium yellow. Its pinkish bill and feet were rendered with a mixture of opaque white and a touch of cadmium red light. The only black and white in the painting is in its wings, tail, and eye.

Rendering Complex Vegetation
Raymond Harris-Ching

SEDGE-WARBLER
1978, watercolor, 21" × 28" (53.3 × 71.1 cm).

As much as anything, the artist's attraction to both subjects shown here was the "wonderful tangle of living things" they represent. For *Summer Wrens*, Harris-Ching sat on a stool, over a period of several days, and sketched out an entire section of a path-side bank of greenery near his home—leaf-by-leaf, like a map. He then took cuttings of all the plants—weeds, grasses, brambles, and ivy—and brought them into his studio, where he patiently reassembled them. To keep them fresh, individual plants were floated in a bathtub until needed. Since they soon withered under studio lights, they had to be rendered quickly in transparent watercolor—right the first time or not at all.

The wrens were drawn and painted from study skins, then painted life-size. The artist also added a cabbage white butterfly and, to the left in the painting, the entrance hole of a bank-nesting wasp discovered while drawing the scene.

Sedge-Warbler, a large-scale painting almost two feet wide and more than two feet high, had its origin in Albrect Durer's *Great Piece of Turf*, painted in 1503. Here, Harris-Ching's idea was to take a "really huge" clump of grasses and perch on it a small, nondescript bird proclaiming its territory. Watercolor sketches of key sections, made at the site to capture the way sunlight actually fell on and around the leaves, proved invaluable later in the studio.

The composition grows from the base of the painting, like the grass. Harris-Ching started with a drawing of considerable detail, then rendered the painting in transparent watercolor.

Despite the detail, he never used brushes smaller than numbers four or five. "My advice to any artist is to use brushes at least two or three sizes bigger than you need," says the artist. "A tiny brush will have a fine point and quite a large brush will have a fine point, but the larger brush will have more body and you will have more control over the point."

Sedge-Warbler was one of the last paintings in which Harris-Ching used straight-out-of-the-tube green pigments to paint the greens. "They always caused me problems. The colors looked too violent, too harsh," he says. Since then, he has abandoned most pure greens, preferring to mix them on the palette from various yellows and blues.

SUMMER WRENS
1974, watercolor, 20" × 27" (50.8 × 68.5 cm).

Creating the Illusion of Wet Leaves
Raymond Harris-Ching

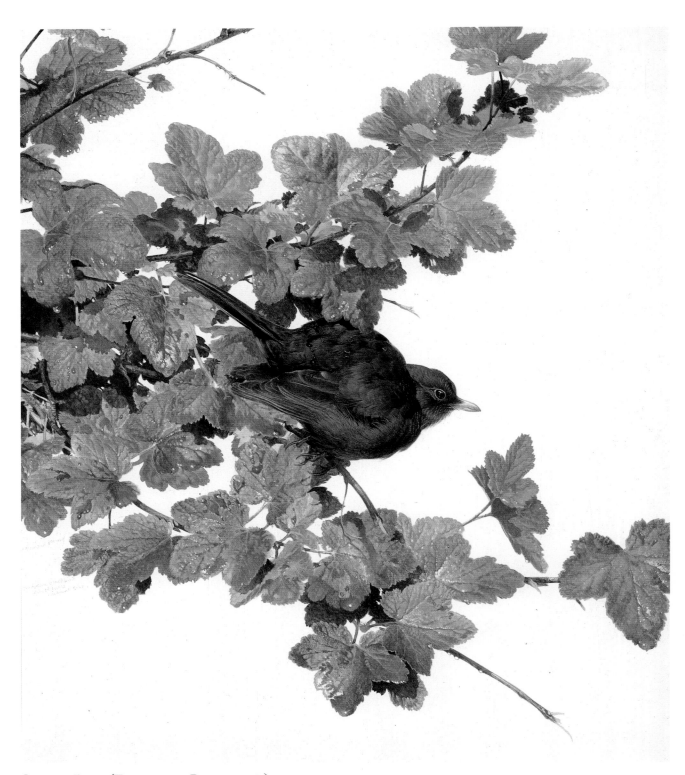

SPRING RAIN (EUROPEAN BLACKBIRD)
1978, watercolor, 18" × 21" (45.7 × 53.3 cm).

Raymond Harris-Ching has drawn and painted birds on every continent but always he returns to his favorite subjects—the commonplace birds: sparrow, song thrush, starling, and blackbird. He believes that such repeated studies of a small group of familiar birds carries the obvious bonus of an intimate knowledge not possible from more widespread or casual observation. Shown here are two paintings of a European blackbird, actually a black thrush, whose flutelike song is a welcome sound in many an English garden.

Spring Rain, rendered in the artist's illustrative style, shows a blackbird vignetted against a white background. The uniform, non-directional lighting enables him to examine all the details of the bird's shape, texture, and coloration equally. *End of Summer*, on the other hand, with its strong interplay of light and shadows, has more in common with Victorian narrative painters. When Harris-Ching works within the confines of the illustration school, he is obliged to paint a blackbird's feathers black. In the study of the dead blackbird, he can paint them a pale silvery gray, reflecting the late afternoon light.

The bird in *Spring Rain* was painted from study skins. Work on the watercolor proceeded from light to dark, entirely in transparent layers, with the exception of a few tight details on the feet and flank feathers which were painted opaquely. Of particular interest to the artist was finding a way to convey sheets of wetness on the leaves. He cut a branch from a hawthorn tree in his garden and drew the leaves into the composition, repeatedly dipping them into a large bowl of water on the studio table. All of the tones and reflected lights of the leaves' wetness were taken, in pencil, to a finished state. "I work quickly and accurately in pencil and I have to discipline myself not to draw what I know is there, but to draw what I see *at this particular time*," says the artist. "I don't make anything up. I set it up and copy it." With the leaves and water carefully drawn, he had only to overlay transparent washes of blues and greens. Later, the artist added droplets of water to the blackbird's back, connecting the bird to the foliage and completing the illusion of rain.

End of Summer is one of Harris-Ching's rare incursions in oil. He found the dead blackbird lying in a hedgerow, took it home, and immediately drew its form onto a small panel. Over the next two days, the bird was painted more or less to completion. Later, the artist added the fairly bare clay background, painted to look hard and stoney. "I wanted to say something about the cycles of natural order, about things coming to an end, but not to be over, not to be finished," he explains. "It is the end of summer and so the young have already fledged and left the nest to become next year's parent birds." The blackbird's wing and foot cast strong clawlike shadows across its body, conveying a sense of vulnerability, even in death.

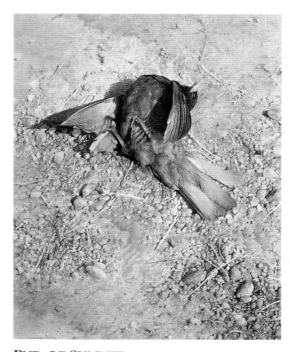

END OF SUMMER
1976, oil, 11" × 14" (27.9 × 35.5 cm).

Painting a Nest

John P. O'Neill

A bird's nest can seem intimidatingly complex to paint. Here, John O'Neill explains the process, using an oriole's woven pouch suspended from the branch of an elm tree. The artist began by drawing a simple sac with a circle at the top, then penciled in contour lines varied to vaguely resemble woven grass. To create the illusion of roundness, grasses on the inside of the nest go one way, those on the outside, in the opposite direction. Some pieces were left sticking out. "A nest doesn't look good if it's too perfect," says O'Neill. "Get the basic structure, then mess it up."

The drawing was traced onto a sheet of rag board, with the oriole's shape blocked out in masking fluid. Starting with a watery raw umber wash, O'Neill brushed over the contoured nest lines, adding darker shadows inside the opening, toward the bottom, and along the edges, to give it form. He built up the little grassy strokes with a mixture of raw umber and Pelikan's Payne's gray, gradually adding more paint and less water. "It's my basic bark or dried-grass shadow color," explains O'Neill. "All the other Payne's grays are too purple or too blue."

Since birds don't weave their nests entirely horizontally (if they did, the nests would fall apart) and use many different pieces rather than continuous strands, O'Neill added near-vertical lines and short, twiglike strokes—some thick, others crooked or broken. To retain crisp edges, he was careful to let each layer dry before adding the next. Where the paint had built up too darkly, the artist worked in reverse, adding white grass in acrylic gesso, which he then tinted with washes of raw umber. He then warmed up the entire nest with a wash of medium yellow acrylic, adding shadows, where grasses crossed each other. Inside lines were further refined and washed again with raw umber, to prevent the area from appearing too blue. Final washes of Payne's gray around the edges of the nest and under the oriole, pushed the structure back behind the bird and added form.

The difficult part behind him, O'Neill proceeded to paint the oriole with confidence. Rubbing off the masking with a rubber cement pickup, he began by laying in the body shadows with a mixture of Payne's gray acrylic and some medium cadmium orange, using damp paper to avoid hard edges. Several transparent glazes of cadmium orange over the entire bird pulled the shadowed and bright parts together. The lighter areas were further intensified with a wash of medium cadmium yellow. Shadows were warmed with a diluted wash of cadmium red, as needed.

The oriole's black wings and tail were rendered in dense, velvety lamp black gouache. Highlights—a mixture of Naples yellow and lamp black—were applied with an old brush that had been "smashed" into the paint, causing the bristles to flair, a technique the artist recommends for feather texture. The pale base on the oriole's bill is made up of a Payne's gray shadow, with a diluted wash of indigo overall. Highlights of white, mixed with a bit of cadmium yellow, give it a shiny, sunlit quality.

After washing more Payne's gray behind the oriole, to indicate a cast shadow on the nest, O'Neill finished the piece by glazing with a wash of highly diluted medium cadmium yellow overall, to convey sunlight. The finished work will appear in a book on the birds of Texas.

ALTAMIRA ORIOLE
1985, acrylic, gouache, watercolor, 20" × 26" (50.8 × 66 cm).

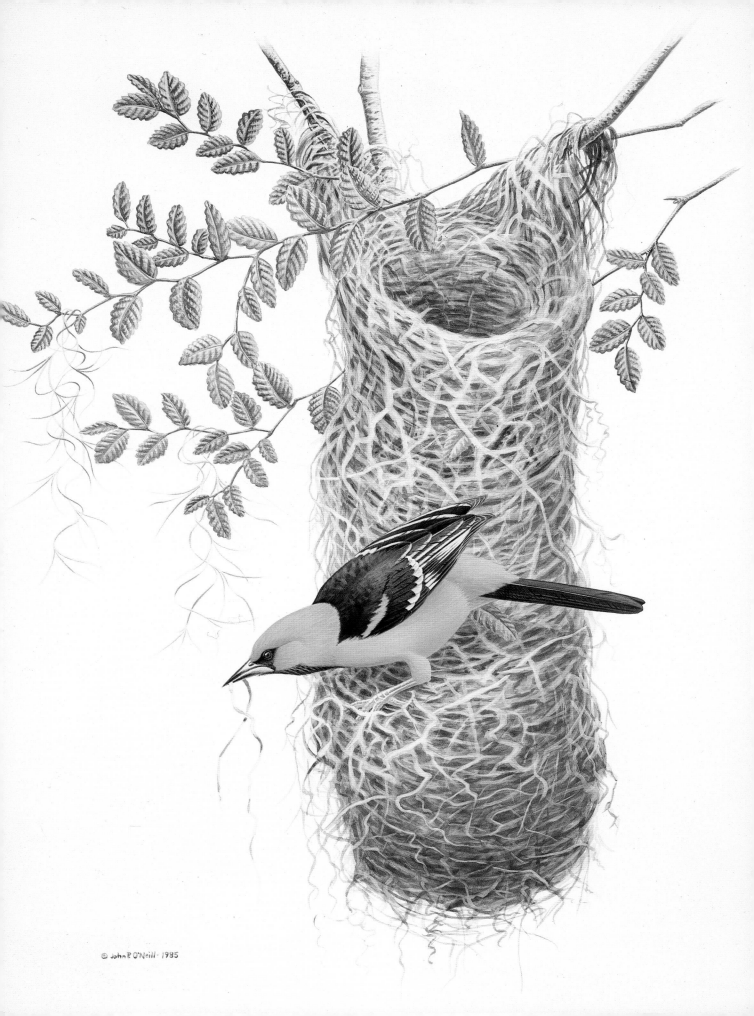

Wildfowl on the Wing

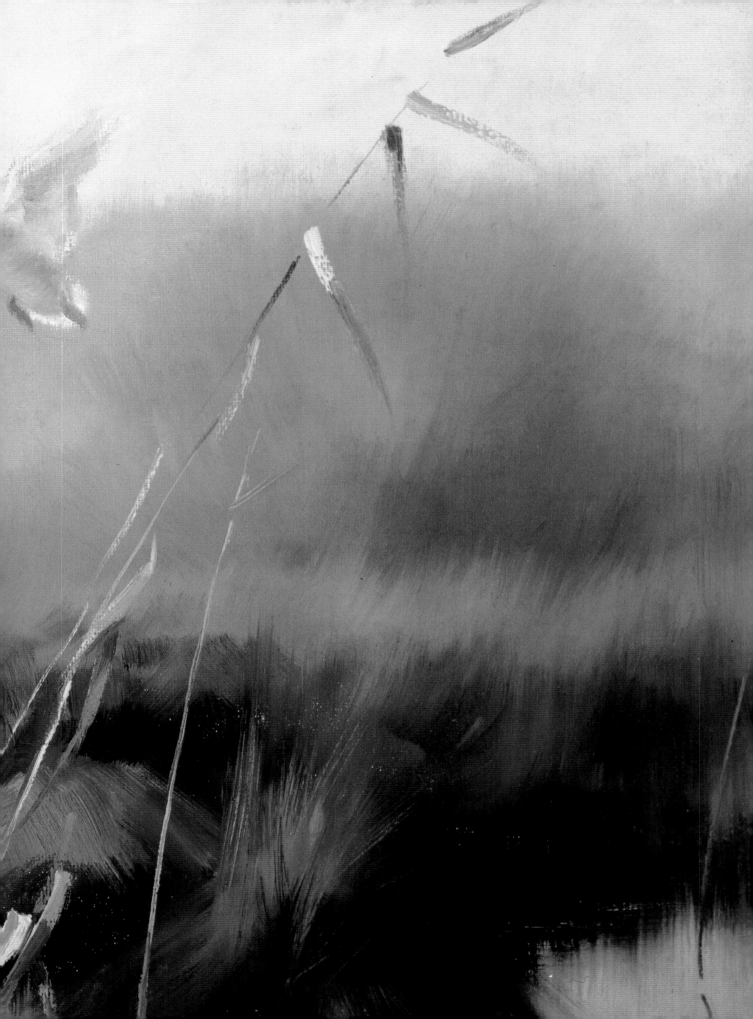

Arranging Flocks of Birds
David Maass

Maass moves tracings around under an overlay to get the positions he wants.

Duck hunting is a sport Minnesota artist David Maass has enjoyed since childhood. "I always think of hunting ducks as being out there in cold cloudy weather, with the wind blowing," he says. "I can probably get more feeling into that type of painting than any I do."

In this case, the scene is a windy October morning on the great delta marsh in southern Manitoba, Canada. Viewed from a blind, a flock of wary canvasbacks drops down for a closer look, contemplating a landing. If ducks feel safe about a place they approach it in unison, with wings set and feet going down at the same time. Here, each bird is in a different position, signalling uncertainty—the flock could take off again just as easily as land.

Working out plausible positions and attitudes for ducks in flight is important to Maass. In a process that involves many overlays and can take several days, the artist draws and redraws individual birds on small pieces of tracing paper, then moves them around under a larger sheet until he finds a suitable composition. His aim is to place the ducks in a pleasing but random-looking pattern. Where they overlap, he makes sure the wings and heads are not confused with each other. Even the arrangement of distant flocks requires careful planning. Ducks and geese fly in V-formations, but if the V is too perfect the result will look unnatural. Maass uses photographs as a backup resource but bases his paintings on years of experience watching waterfowl in flight. "There is something that happens when you stop action in a photograph," he says. "You lose all the beautiful gracefulness of that flock as they are moving through. I try to paint them the way I think you see them as they fly."

Canvasbacks on the Delta Marsh was painted section by section—first sky, then water, reeds, and ducks, with Maass completing each area before going on to the next. The dark color in the clouds reflects darkly in the rough water, providing a strong contrast for the bright whites on the sunlit ducks.

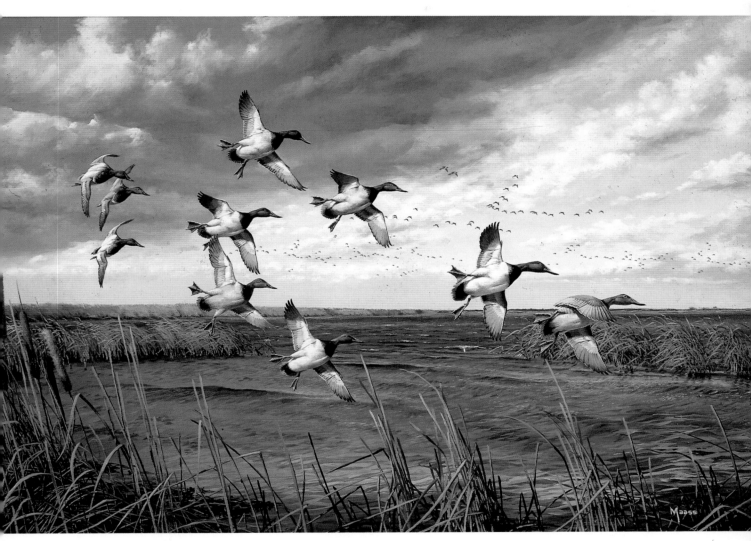

CANVASBACKS ON THE DELTA MARSH
1983, oil, 36" × 24" (91.4 × 60.9 cm).

Using Atmosphere to Define Depth
David Maass

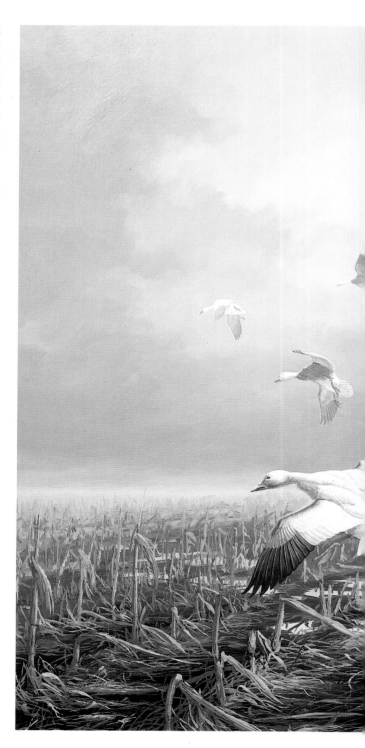

The racket could be heard from afar on this overcast fall afternoon. Then suddenly they arrived, swirling out of the sky like thousands of snowflakes to settle in a western Minnesota cornfield to feed. For artist David Maass, the noise of an approaching flock of snow geese sounds like the roar a crowd makes after someone scores in a football game half a mile away. Until recently, it was thought that snow geese and blue geese were separate species, even though they travel together, but now they are recognized as two different color phases of the same bird.

The low horizon and receding parallel rows of cornstalks give the landscape depth and emphasize the expanse of sky. Distance is further enhanced by the misty atmosphere. Maass has rendered the geese in the foreground with strong color and definition, while those farther back are much grayed and lack detail. The same is true of the cornfield, which pales as it goes back, eventually disappearing in the haze.

Maass painted the background first, starting at the top of the sky and working down. The artist seldom uses pure colors. His palette is mostly a combination of earth tones, which he often mixes with titanium zinc cover white, a premixed combination of zinc and titanium white. Here, the presence of white throughout the painting contributes to the sense of bright light bouncing around under the cloud cover. The far-off geese were painted as part of the background, with white spaces left for the five foreground birds. To paint the soft gray sky, the artist combined ultramarine blue and burnt umber with white, adding tiny amounts of yellow for a greenish tinge, and a bit of alizarin crimson to warm the sky toward purple. The pale slot in the sky gave the birds an opening to drop down from and enabled Maass to paint the darker birds against light and the white ones against the darker cornfield.

The field is composed of earth colors: burnt umber, burnt sienna, yellow ochre, ultramarine blue, and some white—as well as local colors, such as cadmium light yellows and reds. The brightness of the standing water, reflecting the sky at the end of the day like a mirror, is enhanced by surrounding darker colors.

Maass painted the foreground geese last, molding their forms with paint as though they were sculptures. They are basically the same colors as the sky. The blue geese are primarily ultramarine and burnt umber, with breasts and wings warmed with burnt sienna, cadmium red, and cadmium yellow. The white geese are almost pure titanium zinc cover white, mixed with minute amounts of red and yellow to add warmth. Their shadow color is ultramarine and umber, with slight amounts of cadmium yellow and alizarin crimson. The birds' bills and feet are made up of alizarin crimson toned down with ultramarine blue. A touch of cadmium yellow was added to the lightest parts; burnt sienna makes up the shadowed areas.

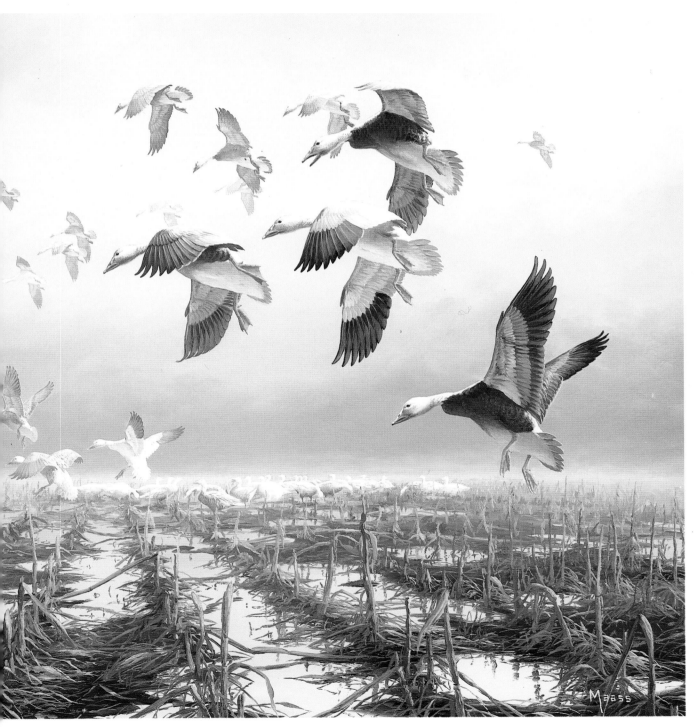

LOW CEILING—BLUES AND SNOWS
1984, oil, 36" × 24" (91.4 × 60.9 cm).

Painting on Location

Keith Brockie

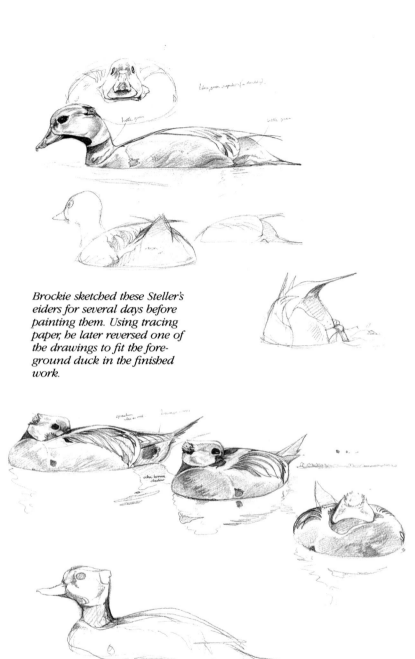

Brockie sketched these Steller's eiders for several days before painting them. Using tracing paper, he later reversed one of the drawings to fit the foreground duck in the finished work.

Keith Brockie saw these uncommon ducks for the first time while camping on an island in northern Norway. The Steller's eiders were feeding on fly larvae among seaweed disturbed by the tide. As the artist sat there watching them on a cold, overcast day, he imprinted on his memory some key details: the "lipped" beak, light green tuft behind the head, and curious black spot on the flanks of the males. "It's always a challenge to paint a new species in the field with little or no preconception about the textbook version," says Brockie. "This painting was a combination of my thirst for visual knowledge of a species that I had never seen before and my interest in their behavior."

Brockie drew and painted the eiders as he observed them through a telescope he had mounted on his camper, parked at the high-tide mark just twenty yards away. The Steller's eiders were squabbling with some common eiders in the same area, and at times the artist's field of vision was a boiling melee of more than fifty ducks fighting for a feeding place. The artist was enthralled by the way they "up-ended" and then surfaced among clinging froth and seaweed, and later couldn't resist draping a strand of seaweed on the tail of one of the ducks, for a comic touch. The crowding and fast action became a major problem in deciding what to paint, however. Brockie eliminated many of the ducks and simplified the action, including a sleeping pair in the open water to further calm the picture down. Working from light to dark, on pale gray paper, he first blocked in the background and worked up the seaweed, water, and froth, before fully painting the main subject.

The white on the male eiders is permanent white gouache, with a wash of cadmium yellow and burnt sienna for the breasts and flanks. To suggest the subtle iridescence of their plumage, which was darkened by the flat light conditions, Brockie used weak washes of ultramarine and viridian on their necks and wing patches. The speckled and barred females were rendered with a mixture of burnt umber, raw umber, and some yellow ochre. He then strengthened the colors in the reflections in the water, gave the complicated mass of seaweed just enough form without overworking it, and finished off the background with a more tonal balance. The picture was completed over a period of four days, working four hours a day.

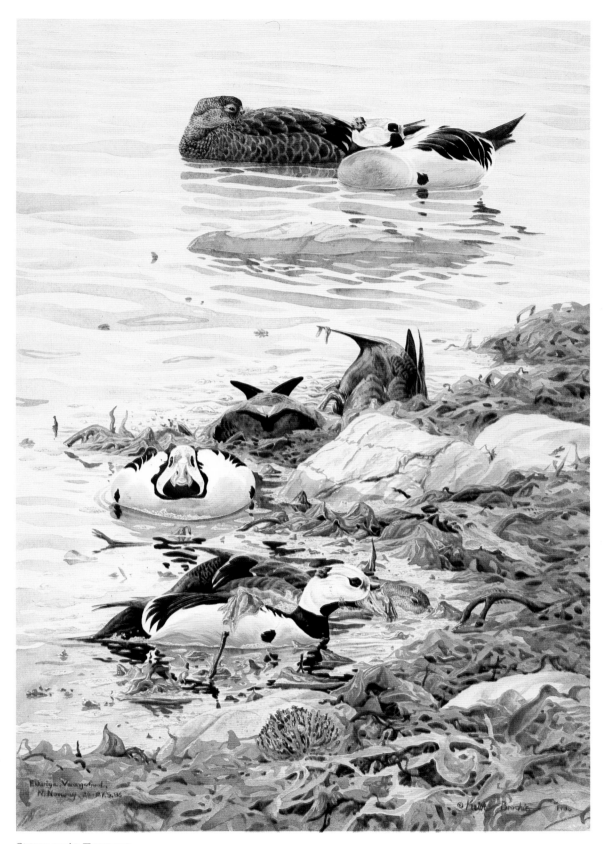

STELLER'S EIDERS
1986, watercolor and gouache, 17½" × 12" (45 × 31 cm).

Field Sketching

Lindsay B. Scott

One spring evening, artist Lindsay Scott came across these western grebes swimming together in courtship ritual, on a lake in Arizona. She drew the birds through a zoom telescope as she sat quietly on the shore, taking her eye away from the lens only briefly to make sure the pen was still on the page. "A zoom scope on a tripod definitely is the best thing for field sketching," says Scott. "It brings the birds up quite close, and at the same time frees both my hands."

When field sketching, the artist uses sheets of gray or green colored paper, which she attaches to a clipboard, to cut glare. She draws with either pencil or pen, using a white pencil for highlights. Scott works loosely and rapidly, spending anywhere from two to twenty minutes per sketch. By the time she is through with a subject, she might have up to twenty thumbnails of just one bird on a single eight-by-twelve-inch sheet.

"I like to field sketch," says Scott. "It's one of the best ways to understand the structure and functioning of animals. In wildlife art, accuracy is essential, and that only can be gained by really knowing your subject matter."

Before starting to work, Scott watches her subjects for at least fifteen minutes or so, to become familiar with their shapes and behavior. Since birds rarely stay put for long, she then quickly draws them in outline form, gradually adding details. With individual subjects, she spots the eyes in relation to the bill and works on getting the correct proportions. If a bird is in constant motion, Scott will select a frequently observed pose, such as whenever a feeding bird raises its head, and adds a bit more to the drawing each time.

When sketching groups of birds, Scott is interested in their relationship to one another. With a flock, she may draw a series of "blobs" across the page, to show how the birds are scattered. "In a way, it's like looking at the spaces between the birds rather than the birds themselves," she says.

Back in her studio, she combines field sketches with memory to make more carefully rendered studies, such as those shown here, done in ball point pen on white paper. Eventually, these "ideas" contributed to the painting *Western Grebes*, shown on the following pages.

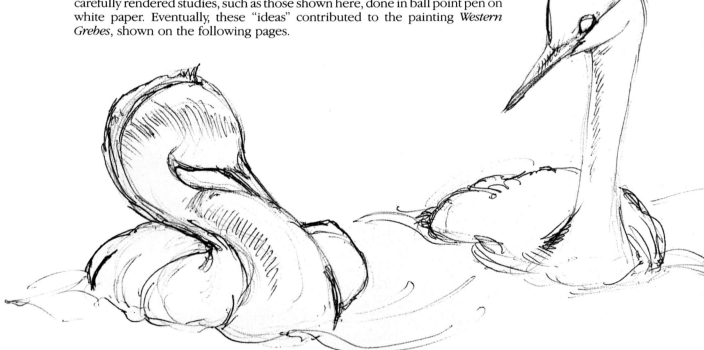

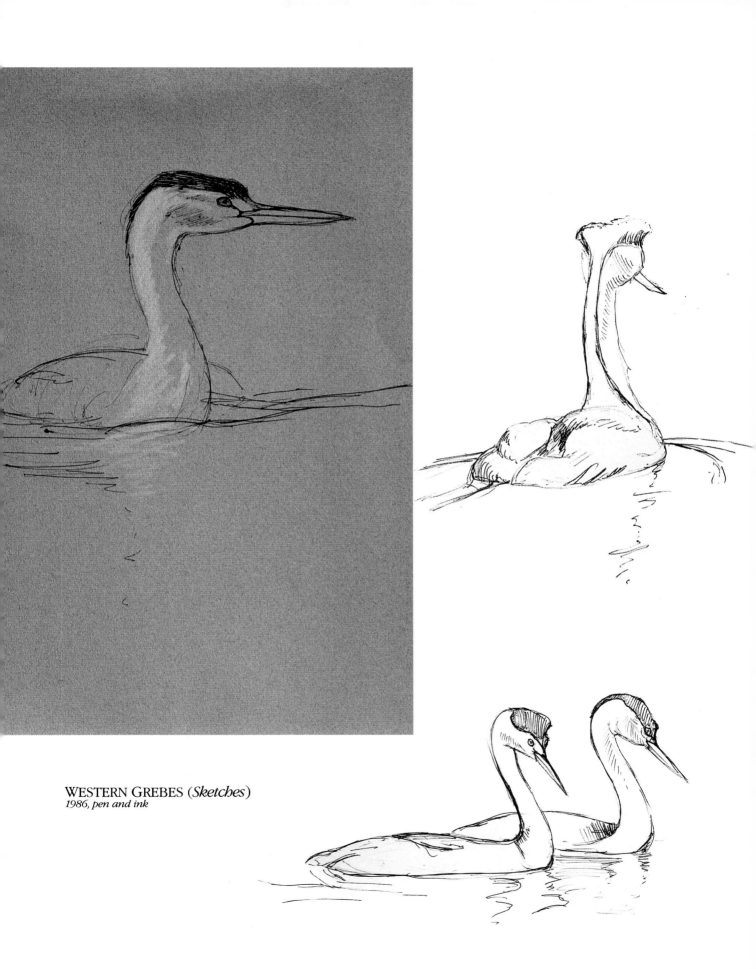

WESTERN GREBES (*Sketches*)
1986, pen and ink

Glazing with Colored Pencil
Lindsay B. Scott

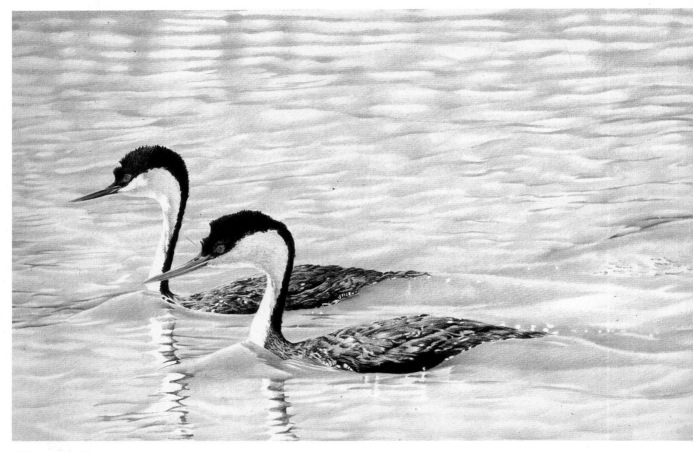

WESTERN GREBES
1986, colored pencil, 9" × 19" (22.8 × 48.2 cm).

An on-the-spot pencil sketch, just one-by-two inches, indicates the horizontal approach Scott planned for the piece. "If the composition isn't successful at that size, it won't be successful in the big painting," says the artist. She further refined the idea in a tonal drawing.

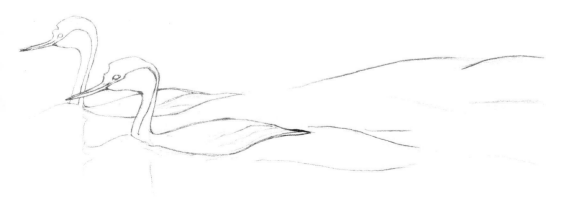

Western Grebes started out as an idea looking for a subject. Artist Lindsay Scott had in mind experimenting with two aspects she admired in the work of Paul Klee: dividing a work into small pieces and contrasting pale colors with bold black forms. Watching a pair of courting western grebes gave her the theme she had been looking for. The graceful black curve of their necks, offset by the predominant pale green water, established the rhythm of the piece. Their gliding passage breaks the surface of the water into ripples and wakes. The artist was struck by how the pastel green water offset the grebes' brilliant red eyes.

Scott chose not to portray the birds' more acrobatic antics but rather show them swimming closely together, to convey the sense of bonding. Since there is a certain amount of aggression in the grebes' courtship, she has them facing slightly away from each other.

The artist let the subject dictate the format—opting for a long, narrow shape to complement the sleek movement of the birds, which seem about to swim out of the picture. "I tried to capture the feeling that you won't see them for long, which is the way it is in nature," the artist explains. Their double wake is critical to the composition. She worked on hot-press watercolor board, which allowed her to get deep tones that could not be achieved with paper. The grebes are the focal point of the piece. Scott drew them in first, so that all subsequent tones

and colors could be played against them. She worked from dark to light, laying in the blacks and grays first, and then glazing all but the very darkest areas with a hard white pencil—to enrich and blend the colors. The result looks much like watercolor. The artist carefully worked around the white areas on the face and throat, which she left blank. The water on the grebes' backs reflects their diving habits.

The treatment of the water marked a turning point in Scott's use of colored pencil. She began with two different cool grays, then worked over them with some blues, followed by a pale green. The surface was then glazed with a very pale cool gray, to convey transparency. "It very much gives you the feeling of water," says Scott, "because that's the way water is—transparent and shiny, with blues and greens showing through."

When it came to painting the grebe's reflection, Scott worked from photographs and her memory. Although a picture stops the motion of water, she finds she has to simplify the image considerably or it doesn't look right. Scott prefers the very hardest type of Swiss-made Caran d'Ache Supracolor I pencils, which keep a sharp point. "Art stores usually carry soft colored pencils, which have a chalky, milky look and rub off messily, almost like oil pastel," says Scott. "If you use the soft pencils it looks like kids' stuff, like what you were doing in school." The subtle results demonstrate the best qualities of working in colored pencil.

Conveying Light with Color

Guy Coheleach

A mallard drake stands sentinel while his mate and two black ducks take their ease at the edge of this sun-dappled stream. The painting vibrates with color—a confetti of blue, green, yellow, orange, pink, and purple. "Each section could have been divided into more detail," says artist Guy Coheleach, also known for his tightly rendered work. But he chose to paint this one loose and easy, following the maxim: "When in doubt, leave it out."

This is a painting about light. Direct sunlight floods the scene from the left, washing over the hen mallard's plumage, striking the edge of the drake's body and highlighting the brilliant white bark of the birch overhanging the bank. Reflected light warms the ducks' sides opposite the sun. Indirect light, bouncing off the water, gives the belly of the drake a golden glow, and the light-struck leaves reflect their colors in the stream below.

Coheleach painted the ducks' feathers in blocks, letting the reaction of light on each plane define its form. The standing mallard's gray underparts are a mixture of burnt umber and blue, with the picture's underpainting of burnt sienna showing through in the lighter part. His head, almost black in the shade, is made up of spectrum violet, grayed with some burnt umber, and a lot of phthalo blue. A lick of pure permanent green dark conveys its iridescence. The drake's back is defined by a streak of cobalt mixed with white, over gray—a reflection of the blue sky beyond the trees. Just two strokes shape his bill: yellow ochre and cadmium yellow mixed with white. The rim of bounced light on his belly is made up of yellow ochre strengthened with a wash of yellow-orange. The duck's foot is bright cadmium orange.

Perhaps disturbed by some slight sound, the female mallard is just awakening, her head twisting forward from beneath a wing. Her beige plumage is composed of a mixture of yellow ochre, white, and some burnt sienna, with burnt umber and a touch of gray in the darker areas. The same disturbance has cracked open an eye of one of the sleeping black ducks. Their bodies, deep in shade, are composed primarily of burnt umber and phthalo blue. "When I'm almost finished, I like punching in the highlights with real heavy paint," says Coheleach. A dollop of yellow ochre conveys the spot of sun on their necks.

The color white is made up of every other color. In turn, it reflects all the colors around it, as demonstrated by the richly complex hues of the birch. Coheleach blocked in the tree with white, combined with just a touch of yellow ochre to warm it. He then came in with burnt umber, darkened with blue for the tree's rings, which were drawn concave to emphasize the trunk's rounded forms. With the paint still slightly damp, he smudged gray overall, to lighten the darks and darken the lights. Yellow ochre and blue were added here and there. Gray over burnt umber yielded the pink tones.

Much of the water is yellow ochre, right out of the tube. Overhanging branches and sky are reflected as pure shots of permanent green dark, permanent green light, olive green, phthalo blue, cobalt, ultramarine blue, and violet. Mixed with yellow, they produce the shades in between. Dabs of icy blue and green, pure hues cut with white, emphasize the warmer colors. Up close, the scene is a jazzy jolt of colors; step back and it pulls together as an impressionistic tour de force.

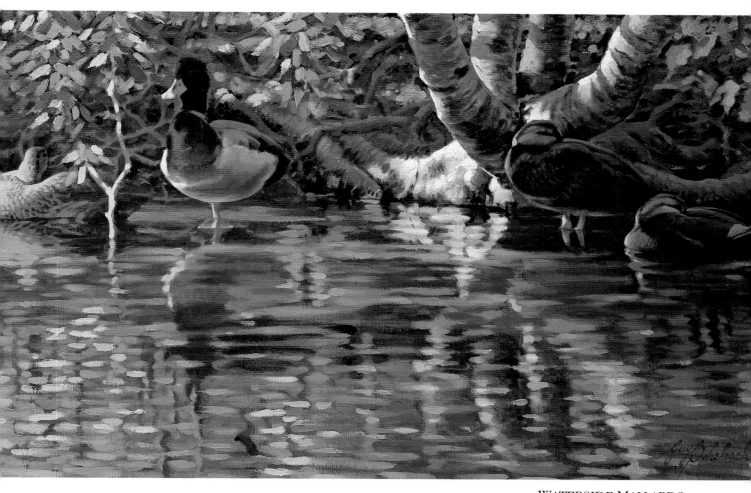

WATERSIDE MALLARDS
1979, oil, 15" × 30" (38.1 × 76.2 cm).

Creating a Layered Effect with Pastels

Lindsay B. Scott

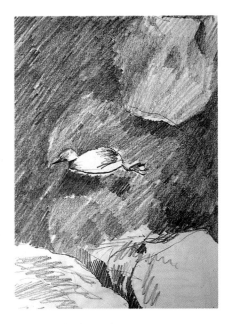

Scott worked out the composition with notebook sketches, later deciding to place the grebe off-center.

In *Dark Waters*, artist Lindsay Scott has chosen the unusual angle of looking almost straight down into water. She explores its properties, from the darkly tranquil deep and submerged rocks—highlighted by sun-shattered ripples—to the surface of the water, with its reflected light and exposed rocks. The bird, a grebe, further helps to define the surface of the water, which it is disturbing as it swims quietly by. It was chosen because its shape, viewed from above, echoes the form of the rocks, while its fluffy rump provides a textural contrast to the rest of the scene. By positioning both the rocks and the bird at the lower part of the picture, Scott gives the scene an anchor and establishes a sense of tranquility.

Scott used both color and the properties of light to help differentiate the various layers. Overlapping them also helped. A particular challenge was to make the submerged rocks look hard, while at the same time softening them with shattered light. Scott worked out the composition with a series of small sketches in her notebook. She decided to place the grebe off-center, later using its brilliant red eye as the painting's dynamic point of focus. To verify proportions and perspective, she did a full-scale drawing on tracing paper, which she then transferred to watercolor board.

When working in pastels, Scott usually creates a middle tone first, leaving the darks and highlights for last. She works from dark to light, blending the colors frequently to soften them. Fixative is applied only at the end. In this case, the artist started with a watercolor wash of ultramarine blue and burnt umber to establish a unity for the water, then painted the water in sepia pastel, with pale green and yellow highlights. The bird and the rocks were left white for a while longer, to prevent their edges from becoming smudged. Also, by painting them on top of the water, the artist could further emphasize the layered effect she was trying to create. The rocks are rendered in shades of cool grays, dark to light, with the same hues repeated on the bird's back. The rest of the grebe is made up of earth colors: siennas and ochres. Scott finished the grebe's body and emergent rocks with thick, unblended strokes, applied like pastel "paint."

To avoid the smudging that is almost inevitable when working with chalk, Scott props the board upright on an easel and draws on it as though with a brush. She enjoys pastel as a change from her more familiar medium, colored pencil; its spontaneity allows her to work larger, with more freedom. She admits though that she is sometimes less comfortable with pastel. "Basically, there are two types of artists," says Scott, "those who draw and those who paint. I draw, and for me, pastel is on the painting end of drawing."

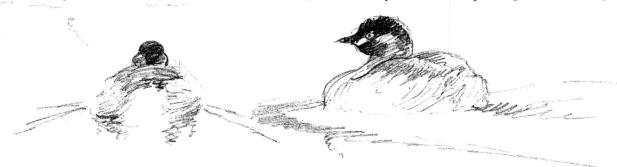

DARK WATERS
1986, pastel, 20" × 22" (50.8 × 55.8 cm).

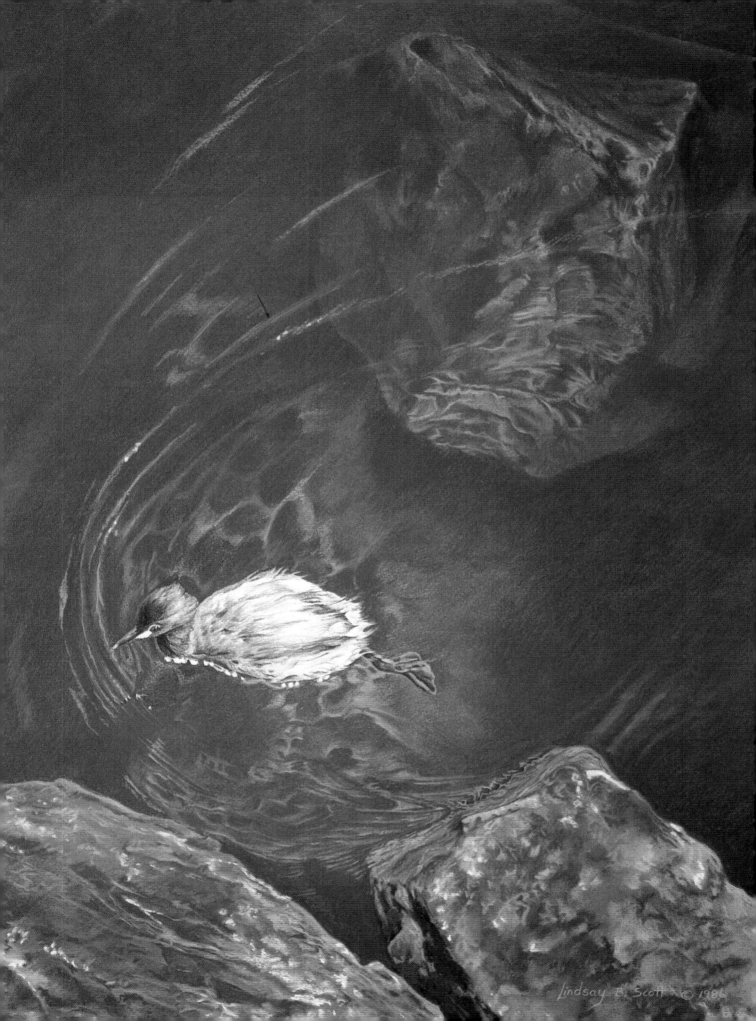

Rendering Complex Patterns
Lindsay B. Scott

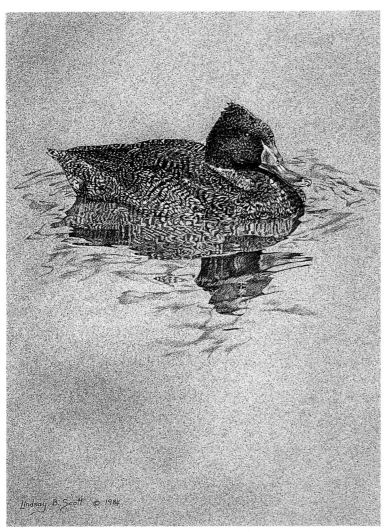

FRECKLED DUCK, MALE
1984, pencil and colored pencil, 10" × 16" (25.4 × 40.6 cm).

For an artist who enjoys the challenge of intricate detail, the freckled duck is a dream come true. Lindsay Scott flushed this pair from a tangle of lignum bushes in a flooded swamp in Australia, while doing field work for a National Geographic Society research grant. She chose to further complicate the subject by incorporating the arching lignum branches into the piece as negative space. The result cuts up the picture like a jigsaw puzzle, leaving the viewer to put the pieces together again.

Her work began with field observations, but the ducks proved so shy that Scott had to finish by sketching captive specimens. She drew the birds first, then built up the water and background, leaving the branches in the foreground blank, with no pencil marks or erasures. One of the most difficult tasks, making the shading uniform right up to the edge of the white, took extraordinary control. It would have been easy for the artist to delineate the edge of the lignum with a dark line but that would have made the branches recede. As it is, the intertwined lignum suggests a screen, protecting the birds from view, just as in nature.

Scott's greatest problem, second to the patience required to work around the branches, was getting the scene in back of them to read sufficiently. "What happened behind the white screen had to make sense," says Scott, "and pull together on its own." She achieved it with tonal continuity. "Doing work in black and white, one tends to work in three shades: a very pale tone, a middle tone, and a dark tone," explains the artist. "But actually, having a full gradation of tones, from one (white) to ten (black), gives a piece accuracy and sensitivity."

In the portrait of a male freckled duck, Scott used its complex plumage pattern to establish the bird's volume. "It's like drawing spots on a leopard, where the shape of the spot tells you what the form is doing," says the artist. Seen from the side, the freckles appear as thin lines; receding over the back, they flatten out. Letting the tone of the paper establish her middle tone, she started with the darkest values on the bird's head, and worked up and down from there. Highlights, added with white colored pencil, finished the piece.

LIGNUM SWAMP, FRECKLED DUCK
1985, pencil, 22" × 17" (55.8 × 43.1 cm).

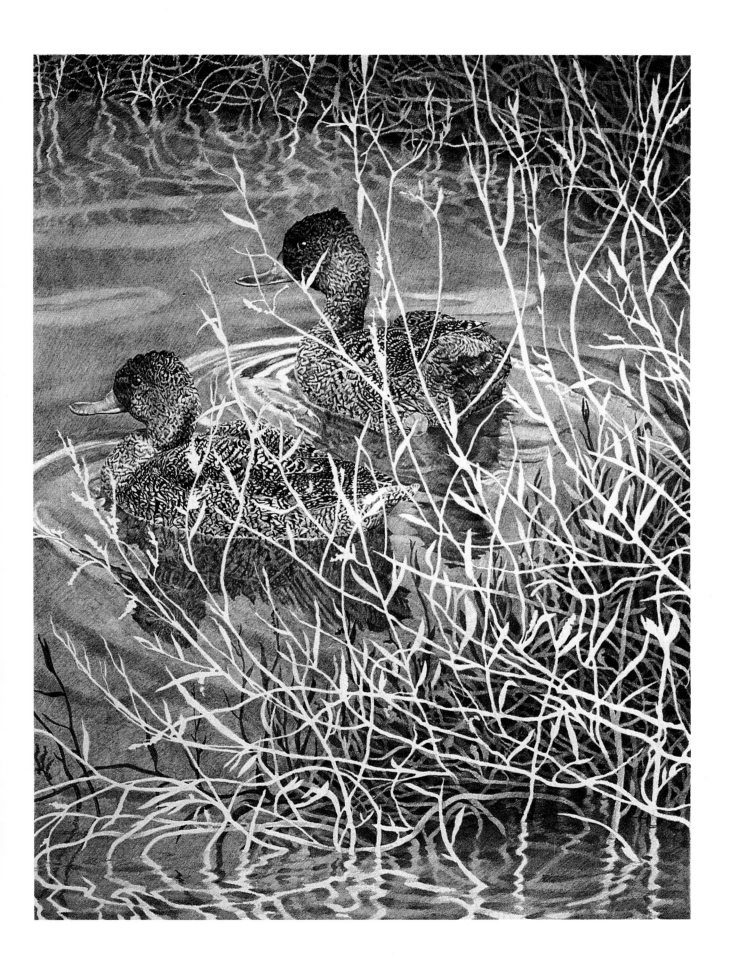

Handling Reflections in Water

Robert Bateman

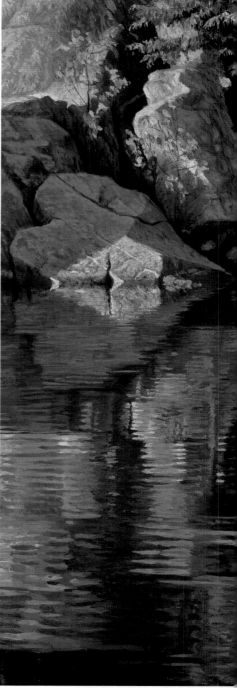

In 1981, Canadian wildlife artist Robert Bateman was asked to paint the official wedding gift from the government of Canada to England's Prince Charles. He chose a scene symbolic of much of Canada—a loon family floating in a lake at the base of a granite cliff in Killarney Park, northern Ontario. The granite is part of the Canadian Shield, which contains some of the oldest and hardest rock in the world. Bateman saw the cliff face as a tapestry—flat and vertical and patterned with cracks, moss, and lichen. Both the cliff and the reflections in the water, broken up into many facets, have a strong abstract quality that the artist found appealing.

Lighting is fundamental to the painting. Most of the scene is in shadow but sunlight glances off the loons, the trees, and the ripples. "I wanted the early morning light to just kiss the surface, sort of skitter across it," says Bateman. The work is done primarily in grays, which Bateman tipped toward green, to convey a woodland feeling.

The range of greens—satiny dark on the heads of the loons, raw green on the trees, and turquoise for the lichen on the rock—coexist in harmony. "I don't mind a variety of greens that are light and airy and don't flicker around in various ways," says the artist. "The only kind of green I don't like is the kind that's in a lot of leafy landscapes. It's like putting your head inside a can of spinach."

The green on the heads of the loons is a mixture of yellow ochre and phthalo blue—although cadmium yellow, phthalo, and ultramarine would have given the same effect, as both yellow ochre and ultramarine have a bit of red in them. The bright green of the hemlocks and birch is the result of cadmium yellow mixed with phthalo blue, and the turquoise on the rocks is yellow ochre and ultramarine, although the blue could just as well have been phthalo, or a combination of phthalo and raw umber. "I don't have any formula," notes Bateman. "There is more than one way to skin a cat, and that really applies to my art. I don't pay any attention to it. It comes without even thinking."

Bateman used photographs as source material for the reflections, which he then simplified. The artist finds that when reflections are made up, they look unnatural. Here, each is a clear-cut and interesting shape, the little patterns within making them seem like small abstract paintings. Many beginners, notes Bateman, paint water "mushy, messy, and vague." But, the artist explains, "water is really like a crinkled, undulating mirror; it reflects everything very crisply, although distorted and broken." To understand the effect, he suggests that his students crinkle aluminum foil slightly, then look at their face in it. "The image will be smashed but it has sharp edges and clean, definite artistic statements."

Bateman has studied water for many years. He once spent a week aboard a freighter observing waves and painting them in quick color sketches. He also likes to sit at the edge of rapids and waterfalls, trying to understand all the volumes and forms. "A wonderful thing to do is sit quietly and look at water a long time, then turn away and paint it," he advises. "There is no use in looking at it while painting because it's always changing. You need to really think about what is happening."

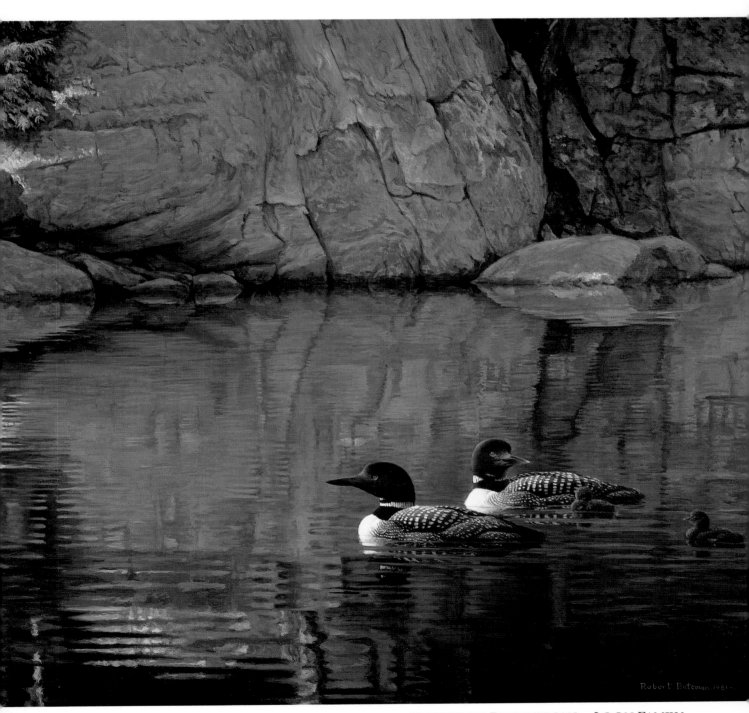

NORTHERN REFLECTIONS—LOON FAMILY
1981, oil, 24" × 36" (60.9 × 91.4 cm).

Suspended Animation
Robert K. Abbett

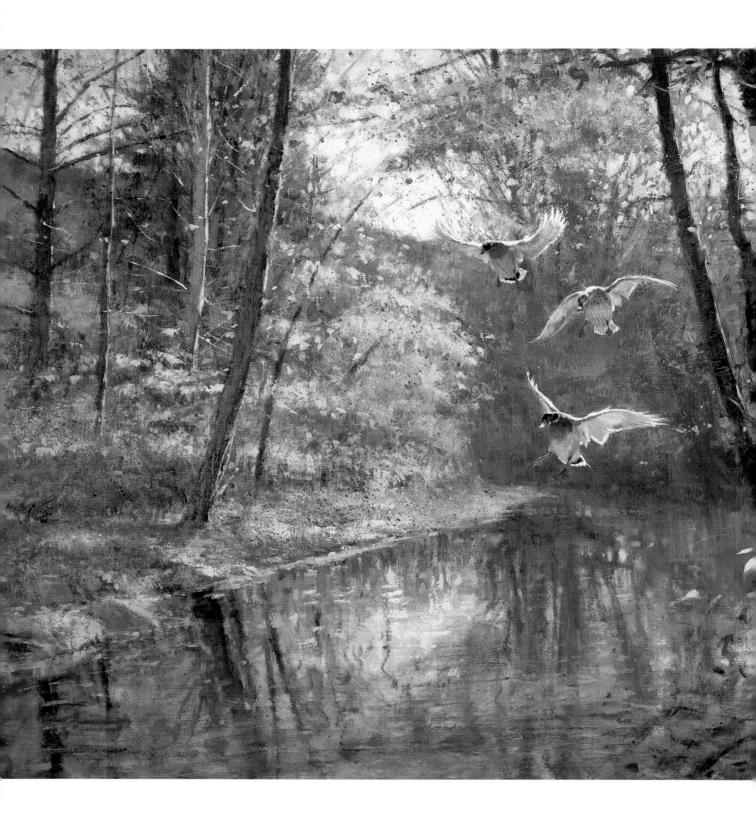

There is a magical moment as ducks drop into a woodland pool, when they seem to hang suspended in the air. Artist Robert Abbett chose to recreate such a scene, observed one autumn at a pond near his home in Connecticut. In keeping with his airborne subjects, Abbett placed the horizon slightly below mid-line to emphasize the sky. To complement the action, he adjusted the position of the shoreline and some of the trees, providing the birds with a column of space and a landing strip.

The mallards are shown in three attitudes of flight and wing position, in keeping with their place in the landing pattern. Ducks come in fast but often don't appear to be dropping quickly because they're able to move about twenty feet forward for every foot down. The action is not unlike that of high-performance jet aircraft, notes Abbett. Their heads are high, beaks dropped, and the trailing edges of the wings curve downward, like the flaps on an airplane. Just before they land, they are going about as slow as they can go, with their wings cupped, tails dropped, and feet braked to slow them down.

Sometimes Abbett takes high-speed photographs of wildfowl landing. He also works with mounted specimens, setting up studio lights to approximate sun and shadow. But the artist puts in most of his time observing them in the field—not always in comfort. For this painting, Abbett sat bundled in a camouflage raincoat for hours, waiting for the mallards to appear. "They come at their pleasure, not the artist's," he notes.

Abbett rarely uses backlighting but here it worked to advantage. The edge light on the ducks' wings focuses attention on them and helps to define the action. The artist was careful, however, to soften some of the edges and let the colors spill back and forth between the birds and the background, integrating the subjects with the scene. "I don't like wildlife art where the bird or animal looks like a decal stuck in the middle of the painting," says Abbett. "The human eye doesn't define every single thing it looks at all at once."

The trees are a mix of earth tones and cadmiums applied side-by-side: pale gold, pale yellow, orange, and even a touch of pink to indicate the variety of autumn color. Since a woodland pool is apt to reflect more trees than sky, it actually can be mostly brown, rather than blue. "When it comes to painting water, the first thing you do is throw your tube of blue paint out the window," notes Abbett. Instead he may use raw sienna mixed with white, which has a somewhat blue cast to it, fooling the eye. "The trick about water is to put it down and leave it," says the artist. "That's one place where it pays to be spontaneous and not fiddle around too much—just do it!"

MALLARD HIDEAWAY
1981, oil, 22" × 32½" (55.8 × 82.5 cm).

Designing for a Small Format
David Maass

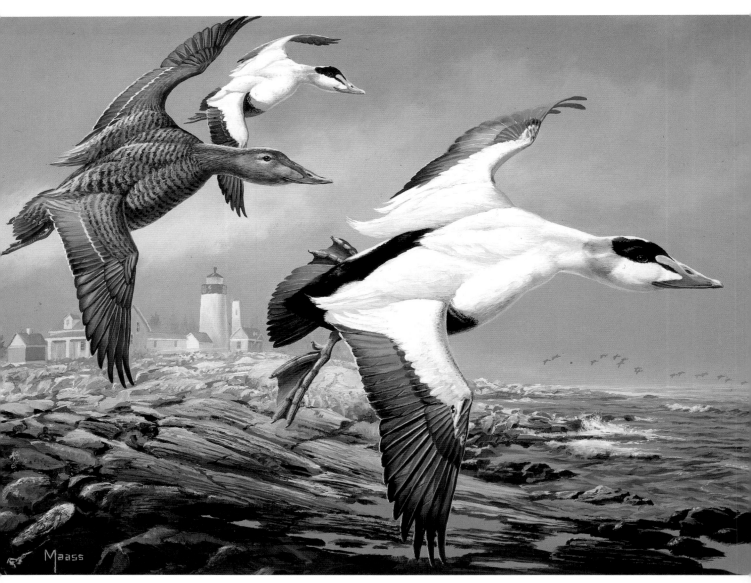

1985 MAINE DUCK STAMP DESIGN—COMMON EIDERS
1985, oil, 18½″ × 13½″ (46.9 × 34.2 cm).

In 1985 thousands of Maine duck hunters carried a copy of this painting with them, postage stamp size. The subject, common eiders flying past the famous Pemaquid Lighthouse, was commissioned by the Maine Department of Inland Fisheries and Wildlife as the second of three state duck stamps painted by Minnesota artist David Maass. Stamps like this one, required in many states for anyone who hunts waterfowl, also are sold print size to collectors.

Maass has painted many state duck stamp designs over the years. He won the 1974 and 1982 Federal Duck Stamp competitions. Since an image like this must read clearly when considerably reduced, the artist needs to be even more design conscious with a stamp than a painting, usually limiting the number of birds to two or three, shown as large as possible against a simplified background.

Painting eiders was a particular challenge, since the ducks are coastal and were unfamiliar to the Midwestern artist. Eiders fly very differently from other ducks, Maass notes. They are heavy bodied, with stubby tails, wings set far back, and feet that stick out behind them. With their heads thrust out almost lower than their bodies, they have a thick-necked look. Flocks characteristically travel strung out and low over the water and are almost never seen over land. To capture the unique "eider look," Maass visited Maine for research. He also relied on study skins and video tapes of the ducks in flight.

Maass works mainly with a direct, wet-on-wet approach when possible, using little underpainting or glazing. He completes one area of a painting at a time, premixing the colors and doing little or no mixing while painting. In this case, the birds were masked out while he worked on the sky first, followed by the water, rocks, buildings, and then the ducks.

The drakes' striking white plumage is set off by dark rocks and the heavy sky. Maass used primarily titanium zinc cover white, mixed with cadmium red and cadmium yellow for the body color. The velvety black on their heads and wings is a combination of ultramarine blue and burnt umber, with the near duck's left wing tinted white and blended off smoothly, to convey a sheen. Their distinctive green neck patch was rendered in white mixed with some cadmium yellow, plus a touch of ultramarine blue and yellow ochre. The hen eider was painted primarily in yellow ochre, burnt sienna, and burnt umber.

To convey the rough-looking water, Maass draws with the edge of his flat red sable brush, as though doing a pencil study in paint. The pools of water in the right foreground are ultramarine blue, mixed with burnt umber and white. "If you just saw that blob of color on a piece of white paper, it wouldn't do much for you," says Maass. "The dark rocks around it give it the brightness that you see." In the end, the artist was pleased with the way the ducks were brought out with strong lighting, and the distant buildings pushed back into the haze. He considers the Maine painting one of his strongest stamp designs.

The artist established the format with many designs and overlays.

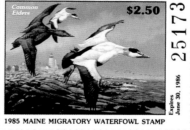

The 1985 Maine duck stamp is shown here actual size.

Mastering Action

Manfred Schatz

Manfred Schatz is the recognized master of animals in motion. He captures wildlife as it actually is seen—in quick, often shadowy glimpses rather than in sharp focus. By leaving our unnecessary details, he manages to convey the very essence of wild things.

Here a mallard, about to land, backstrokes furiously, its wings a blur. The soft, sweeping brushmarks may look easy but they represent a lifetime of close observation—and extraordinary talent. "If you don't know what the essence of a mallard is, look at a Schatz painting," Montreal wildlife art historian, David Lank has said. "He understands the mass of each bird in the air, and also their angles of flight." His rendering of the landscape—from clumps of marsh grass to an old rail fence—is equally impressionistic. For Schatz, the setting is as important as the subject.

Mallards were one of the first birds Schatz saw after a four year internment in a Russian prison camp. They are a theme the artist returns to again and again, even though he knows them well after having watched them for years, often under grueling conditions. Yet whenever he paints a new picture, Schatz goes to the marshes to observe them again, so their image will be fresh in his mind.

Schatz's subdued palette reflects the misty, foggy atmosphere of his settings—the marshes near his home in West Germany, or the dark, snowy winters of Sweden, twelve hundred miles to the north, where he spends time each year at a wilderness camp, sketching. "The reason he doesn't use clear colors is that he chooses to paint in areas of high humidity, where the water in the air breaks up the light," explains Lank. "With his background, he can't paint a bright green head on his mallards or he wouldn't get the mood he is trying to create."

Schatz works unceasingly. "When I have finished an especially well-done painting I am content for about two days," he says. "Then I know I could do better, and this feeling drives me to go on. One lifetime is just not enough to paint all the wonderful things in the world."

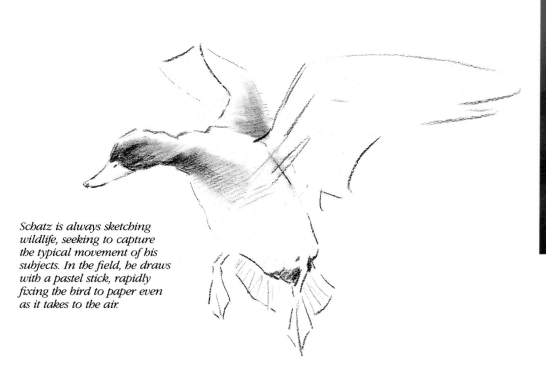

Schatz is always sketching wildlife, seeking to capture the typical movement of his subjects. In the field, he draws with a pastel stick, rapidly fixing the bird to paper even as it takes to the air.

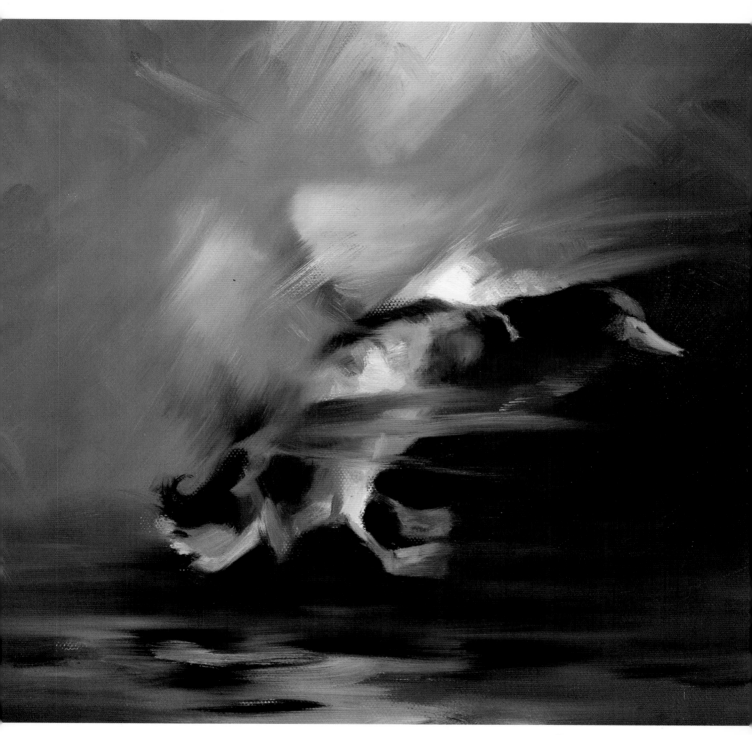

FEATHERED MAGIC
1974, oil, 15" × 21" (38.1 × 53.3 cm).

Conveying Motion

Manfred Schatz

Manfred Schatz eliminates more than he includes, leaving the viewer to fill in the details. "For example," he says, "If I paint a patch of grass in a naturalistic way, I can paint each blade of grass without any effort. But to do this in the impressionistic style, with three or four brushstokes, to make the grass look like grass in form and color, so it shows how it is moving in the wind, how it is moist from rain or dried out by sun, that is art; that is creating something; that is art coming alive."

Nevertheless, his loose impressionistic style conveys uncanny accuracy. Add the artist: "I only attempt to paint what the human eye can see, according to the actual momentary unreflective impression of the retina. For instance, take an ascending mallard. The movement happens in seconds. The speed of the ascent doesn't give me, nor my eyes, enough time to recognize the details. All I am left with is an impression. My impressionistic style is capable of capturing this view, for it combines time, space, strength, and movement in one single moment."

LOW AND FAST
1979, oil, 22" × 16" (55.8 × 40.6 cm).

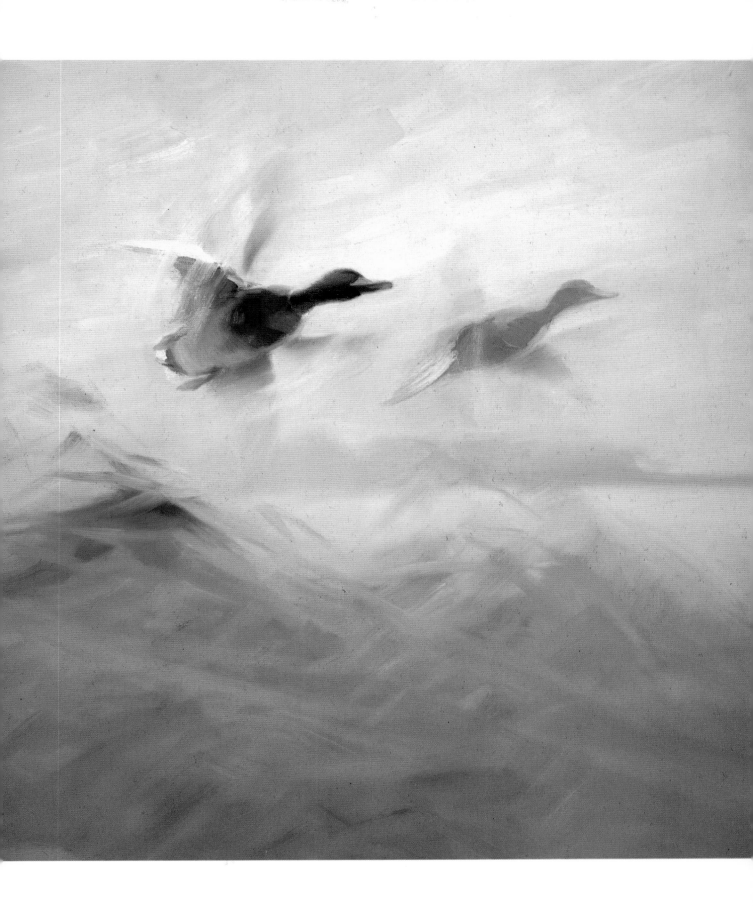

The Night Hunters

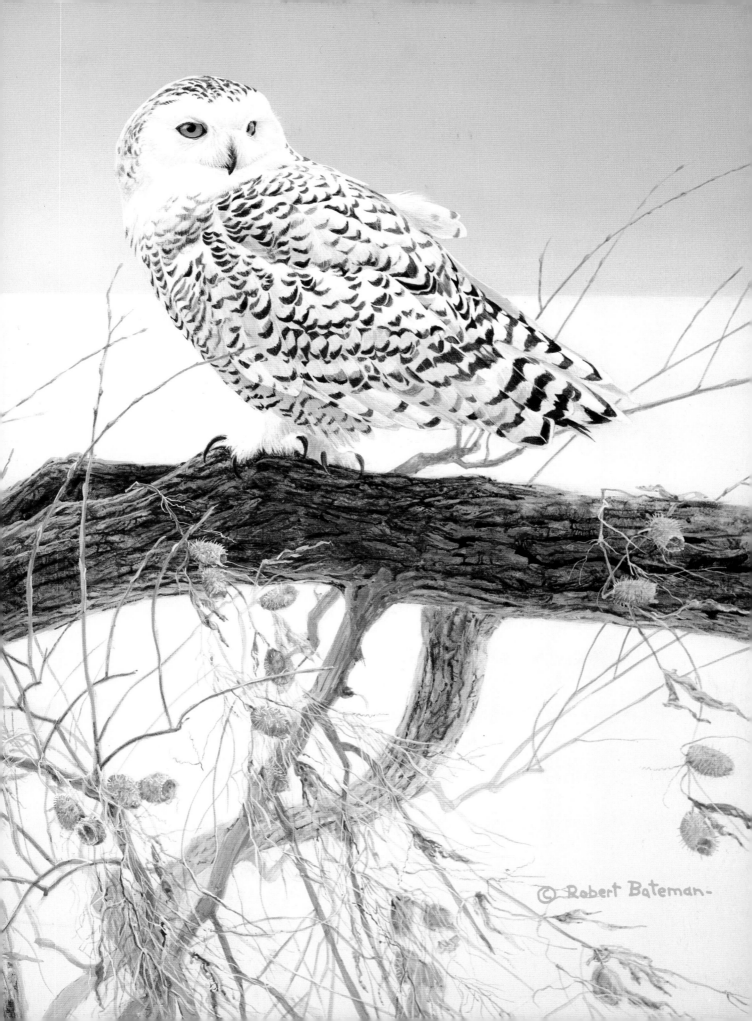

Interpreting Nature
Raymond Harris-Ching

For artist Raymond Harris-Ching, the idea for *Barn Owl, with Bat* came out of the simple act of holding a dead barn owl. The bird was brought to him one evening, found by a neighbor near some outbuildings on his farm in Sussex, England. As he opened and closed the owl's wings, turning it from one hand to another, and wondering at its delicate pattern and soft coloring, he thought it might make an interesting painting—coupled with a bat. "One is soft and white, the other small, dark, and hard-winged," explains Harris-Ching. "A kind of good and evil if you like, excepting that the white 'pure' owl is in fact the unexpected predator!"

The artist wired the dead bird into position and painted it life-size. When he draws from a study skin, he reconstructs the bird from a mental image of what it ought to look like. But working with a large, rather elaborate dead specimen can lead to "slightly strange and unreal effects." What is there before him takes on its own set of circum-

stances and may not coincide with the more familiar concept of "barn owl." But then, "the business of art is not just to copy nature," he says.

Because the freshly dead barn owl was decomposing, Harris-Ching found it necessary to draw and paint it to completion first. The bat, a pipistrelle, was to be done from a study skin in the artist's collection and could be completed at any time.

The owl's back is essentially a transparent watercolor mixture of raw sienna, raw umber, and a touch of yellow ochre. The white underparts are painted more or less opaque, with a mix of permanent white and cerulean blue gouache. The bat was rendered primarily in burnt umber, with a touch of ultramarine blue for the deepest browns. There is nothing in the painting except the shapes of the bat and the owl. The pure white space of the watercolor paper is as much a part of the composition as the bird and its prey.

One of Harris-Ching's many collector's cabinets contains the skulls of all the British owls and most British and European waterfowl. He refers to them now and again for anatomical details or "just to draw for the pleasure of drawing." Here are shown the skulls of a little owl (top), tawny owl and barn owl (right), along with the bill of a sea duck (left). "To watch the preparation of a museum study skin of a barn owl is perhaps the only route to appreciating the remarkable depth of an owl's feathers," says the artist, "for the actual body beneath all that fluff and bulk is revealed to be hardly bigger than a thrush!"

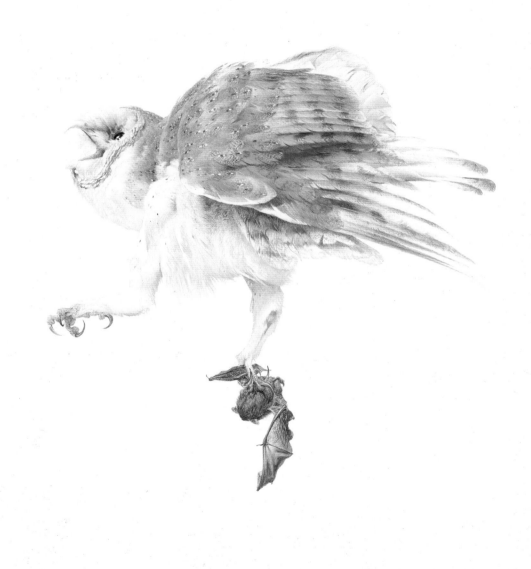

BARN OWL, WITH BAT
1975, watercolor and gouache, 20" × 26" (50.8 × 66 cm).

Using Limited Color and Repetitive Patterns
Robert Bateman

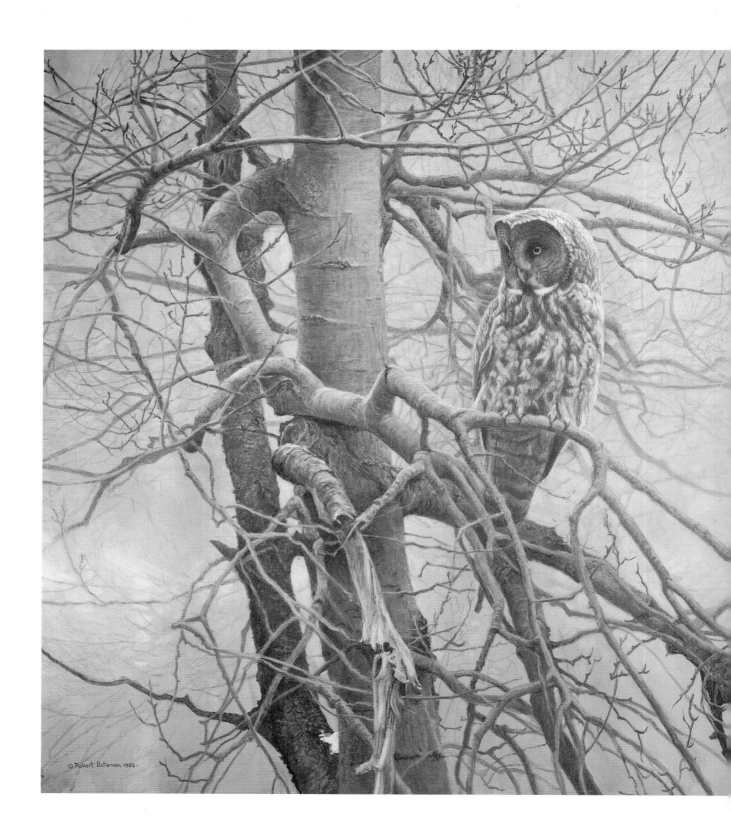

Its deep voice booms through the northern forests but the great gray owl—the largest owl in North America, with a wingspan of six feet—is mysterious and elusive. To convey its ghostly quality, Canadian artist Robert Bateman placed the huge bird against a misty background, in a tree of similar pale coloration. The tree he selected—an aspen—was far enough down his steep driveway so that he could stand above it and paint its more interesting top branches.

The main axis of the aspen dictated the composition—Bateman wanted it a third of the way in on the left. Placement of the owl proved more difficult. The artist moved a bristol board cutout of the owl over the surface of the painting until he found a pleasing location. Its position is more central than most subjects in Bateman's work but is compensated by the off-balance quality of the tree.

Bateman uses a pattern or shape, found in the feathers or structure of a subject, as a repeated theme throughout a picture. With *Ghost of the North—Great Gray Owl*, it gradually became clear to him that the background was becoming an allegory for the owl. The bird's two oval discs, on either side of its beak, are echoed by the curving shape of the branches on either side of the trunk. He began to elaborate on the twigs, making them radiate out like the feathers of the owl's face. Stepping back from the painting, Bateman saw the owl-like forms of the setting take on further definition. He even repeated the bird's white "whiskers" in the larger scheme, as two patches of pale sky on either side at the lower third of the picture.

To keep the painting flat, translucent, and pale, the artist used a limited palette of soft beige-gray, with turquoise and olive accents, knocking it back all along with thin milky washes. At the end, he patted the painting evenly across with a sponge, using white paint mixed with a touch of raw umber and Payne's gray thinned with some matte medium.

GHOST OF THE NORTH—GREAT GRAY OWL
1982, acrylic, 49" × 37" (124.4 × 93.9 cm).

Capturing the Comical Look of Baby Owls

Guy Coheleach

"All owls are characters, especially the young ones," says wildlife artist Guy Coheleach. "These baby saw-whets tried to act fierce but they were just silly looking, really comical." Only seven inches high, saw-whets are among the smallest owls in North America. Adults are streaked dark brown and white but the young are often a tawny rust color, with broad white eyebrows.

Coheleach sketched his subjects, which had been rescued from a fallen nest, as they perched in an evergreen tree in a local park. He acknowledges the ease with which he became caught up in their personalities: "The tall baby in front was the daring one. Above him is the fat toughie of the group. In the middle is the runt, which probably got fed last, and the one on the far left, under the branches, is the real cool cat. He's sitting up there like he's invisible."

To emphasize their fuzziness, one of the most appealing aspects of baby birds, the artist added large tufts of down on their heads and breasts, dark against light and light against dark. Their two-toned plumage is made up of burnt sienna and yellow ochre.

The way Coheleach handled the lighting adds a sophisticated element to this otherwise straightforward group portrait. The light on the branches is coming from above right but the light on the owls is indirect, bouncing up from below. It is reflected in their eyes as highlights, illuminating the upper-left corner and bouncing across the lens to catch the lower right rim as well.

Unlike many wildlife artists, Coheleach does not hesitate to portray the cuteness of baby birds and animals. He explains, without apology, "There's a lot more to life than just doing grand things. If you can put a smile on someone's face, you've got an obligation to do it."

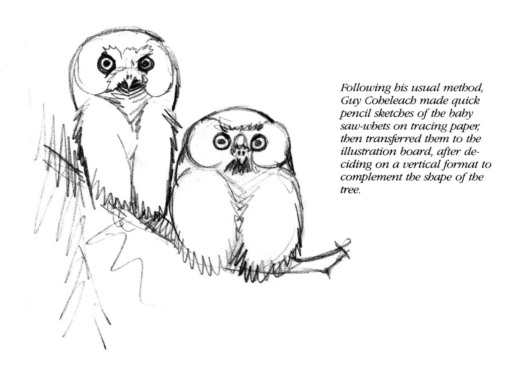

Following his usual method, Guy Coheleach made quick pencil sketches of the baby saw-whets on tracing paper, then transferred them to the illustration board, after deciding on a vertical format to complement the shape of the tree.

BABY SAW-WHET OWLS
mid-1970s, gouache,
16" × 20" (40.6 × 50.8 cm).

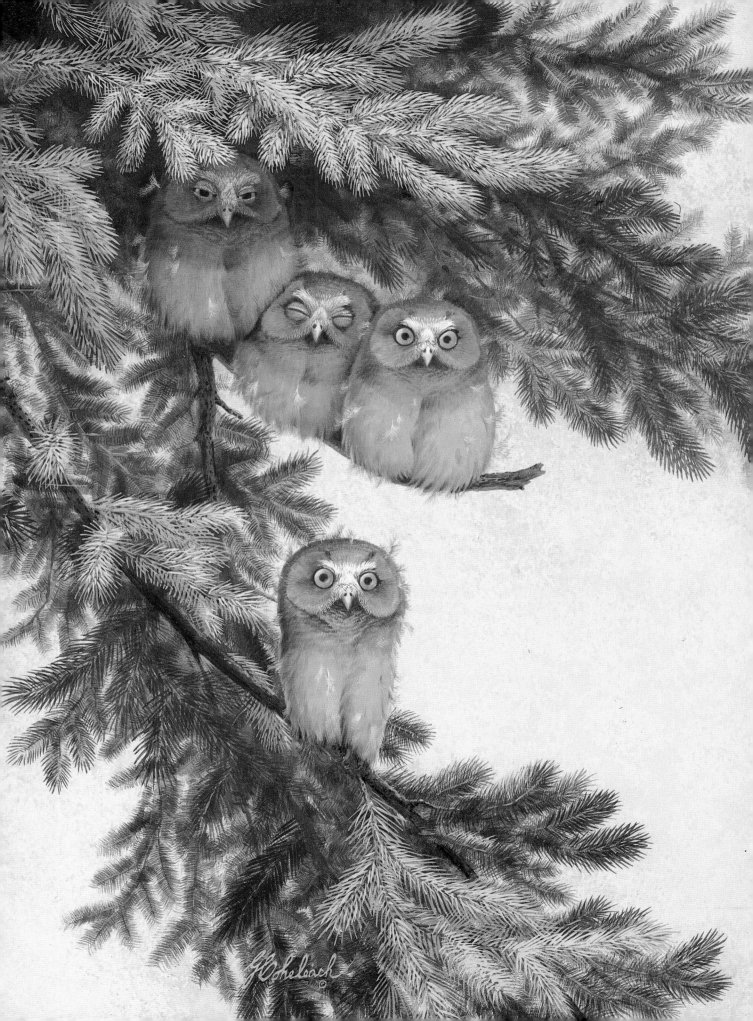

Using a Palette Knife to Paint Bright Colors
Guy Coheleach

Come up with an idea. Rough it out quickly. Paint it loosely. Chances are the results will be more pleasing than more carefully rendered work. That is what happened with this painting of a snowy owl by Guy Coheleach, which the artist presented to his friend and mentor, wildlife artist Don R. Eckleberry. The picture was done in the spirit of a field sketch, preliminary to a larger, more detailed work. Coheleach prefers the spontaneity of the "sketch," which took less than half an hour to paint; the owl was finished in ten minutes.

The scene is a cold and overcast winter afternoon on Jones Beach, on the outskirts of New York City. The snowy owl, a seasonal visitor from the Arctic, sweeps low in pursuit of a rat dashing for cover. The rodent is closer to the fence than the owl is to it, but the bird is faster and gaining ground. Will the rat reach the fence—and possible safety—in time, or is the owl about to snatch a meal? By positioning both so that each has an equal chance to succeed, the artist has created visual tension. The curves and rhythm of the fence keep the eye moving over the surface and hold the viewer's attention.

The subject was a familiar one for Coheleach, an avid birder who often stalked snowy owls on the winter dunes. To recollect the scene, he relied on memory and his observations of two of the birds, which had been live-trapped for the painting and later released.

Coheleach's palette is limited to yellow ochre, burnt umber, and white, with a touch of ultramarine blue to cool it down. He underpainted the board dark, then laid on the thick paint with a palette knife, a technique he prefers when working with large areas of pure bright colors. "With a brush, each bristle creates a minute indentation on the surface of the paint," the artist explains. "There will be gray shadows for each one of those little hairs on the brush. If you are trying to show bright white paint, use a palette knife. Its smooth stroke leaves no shadows."

When using a palette knife, Coheleach scrapes the paint downward and to one side, pressing the knife close to the surface at the top of the stroke and easing up toward the bottom, so that the layer of paint goes from thin to thick. Since paintings typically are lit from the top, the lighting will illuminate a smooth surface. The artist plans his work ahead so that the stroke stops at a juncture in the picture—in this case, where the snow joins the grass or the line of the fence.

To create the fence pickets, Coheleach scraped off some of the white paint down to its dark underpainting with the butt end of a brush, then filled in with more white. The modest-sized work, one of Coheleach's earlier oils, hangs in Eckleberry's home on Long Island, near the barrier beaches depicted in the scene.

DON ECKLEBERRY'S OWL
early 1960s, oil, 24" × 12" (60.9 × 30.4 cm).

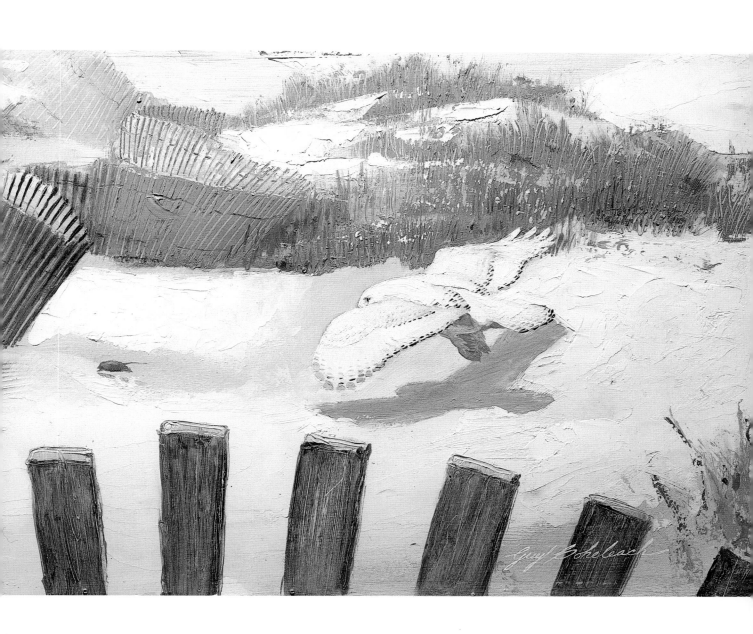

Upland Game Birds

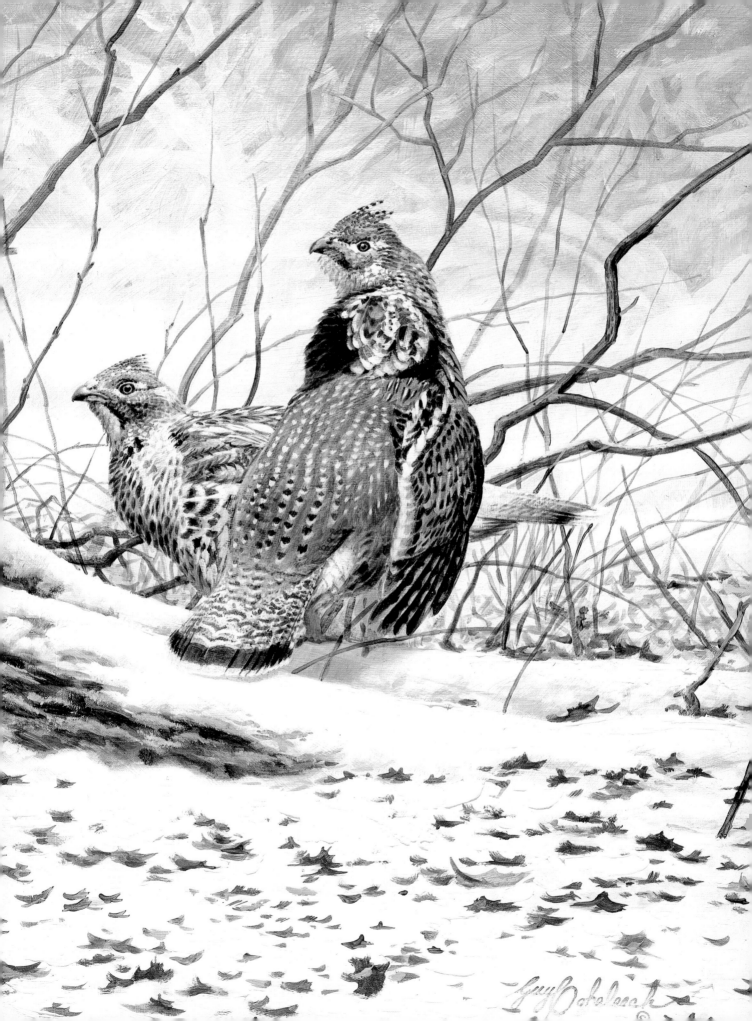

Defining Form with Reflected Light

David Maass

A pair of woodcocks flies out of an abandoned orchard in New England, where they have been probing the ground for angle worms among the rotting apples. Seen through a morning mist, the birds are rendered softly. The light is coming from the left, highlighting the tops of their bodies and shining through the translucent feathers on the near bird's wing. Reflected light illuminates the underside of the woodcocks and helps to define their form.

With any round three-dimensional object, the area next to a highlight is darkest, followed by a gradual lightening again toward the area of reflected light, on the opposite side of the highlight. The color of reflected light is always cooler and less intense. With birds, feathers soften much of the light, so the effect must be even more subtle, says artist David Maass. "As I am painting, I'm always thinking of highlights and reflected light," he adds. "Reflected light sounds simple, but it isn't. If it's overemphasized, it takes away from the highlight and you end up with something that looks artificial." Light changes as the day progresses, becoming warmest in the early morning and late afternoon, and less warm at midday. Overcast and time of day also determine the intensity of the reflected light.

The woodcocks' tawny plumage is a mixture of yellow ochre and burnt sienna, with a touch of burnt umber. To indicate highlights on the back of the near bird's head and leading edge of its bill, Maass warmed the colors with very slight amounts of cadmium yellow and cadmium red. For the reflected light on its underside, the artist cooled and darkened the plumage colors. He painted the background first, back to front, starting with the most distant firs, which are a straight gray, to the fairly strong color of the foreground trees. Maass makes greens from a base of ultramarine blue with burnt umber and some cadmium yellow, adding more cadmium yellow and yellow ochre for the richest hues. With the birches, which have a strong side and back lighting, he placed the darkest tones next to the highlights, then gradually faded them around to the back of the trunks, where the color brightens again with a cool, slightly greenish reflected light.

Maass wanted strong color and light on the worm-eaten apples as well, to enhance the otherwise somewhat gray painting. "It's hard to paint an apple without overemphasizing the red," he says, "but by using just a tiny bit of red, with darker colors behind it, you can actually make it look redder than if you had painted the whole thing red." The apples are rendered in a full range of colors, from alizarin and burnt sienna—mixed with some cadmium yellow and white— to burnt umber and ultramarine blue.

ABANDONED ORCHARD—WOODCOCK
1984, oil, 36" × 24" (91.4 × 60.9 cm).

Balancing Subject and Background

Richard Casey

SNOWFALL ON A HILLSIDE PASTURE
1986, oil, 47" × 32" (119.3 × 81.2 cm).

Pheasants were introduced about ten years ago to the Maine island where Richard Casey lives. In winter, the artist feeds them with cracked corn. One day when Casey was out hiking, he came across some of the birds tracking through a field, in an area where the first settlers had lived, now long abandoned. As they moved out of sight, Casey wondered about newcomers, like the pheasants and himself, whose imprint on the land also will fade with time. Those thoughts were on his mind as he painted *Snowfall on a Hillside Pasture*.

Knowing it would be difficult to combine a brightly colored dominant bird with a simple background, Casey decided to paint the pheasant first and work everything else around it. "I wanted to see how substantial his presence was and what I had to do to balance the composition and yet keep the bird the focal point," he explains. He worked out the pheasant's size and placement intuitively, roughing it out in the upper right with broad strokes.

Casey kept the bird's bright plumage subdued to suggest the warm gray light of a winter's day. He prefers Belgian-made Blockx brand oils, for their richer texture and earthier colors. The artist puts out many colors at a time, grabbing a bit here, a bit there as he works, gradually building up form with many layers of glazes over an opaque base. Here, the dark copper of the pheasant's breast contour, back, and upper legs is made up of thin glazes of Vandyke brown, brown madder alizarin, alizarin crimson, burnt sienna, and Italian earth. The bird's bright orange side is composed of white, yellow ochre, and cadmium yellow light, with a touch of raw umber to "dirty it up a bit." In places, Casey feathered in bits of the coppery color to make the transition. The blue of the wing is made up of ultramarine blue, gray of gray (a Holbein color), and a gray mixed with lots of white. The tail is basically raw sienna, glazed with transparent brown and burnt sienna, and barred with charcoal gray.

To capture the iridescence on the pheasant's neck, Casey laid in a blackish base composed of burnt umber and Prussian blue, then added overlapping crescents of Prussian blue, cut with white. Where the sheen changes, at the top of its head and lower neck, he substituted Prussian green. The bird's face is basically glazed with cadmium red deep and raw sienna. Says Casey: "I felt like a cartographer mapping out its splendid, intricate geography. Each color fragment developed slowly until I was able, finally, to step back and see this jewel-like creature move across that pasture of snow."

To anchor the pheasant on the stark white panel, the artist next added the grasses, which he had collected and brought into the studio. Some worked and he left them; others didn't and he painted them out. But Casey knew he wanted at least one stalk going up and out of the frame. When he realized more weight than grass was needed to balance the bold bird, he added a fence post, repositioning it several times before he was satisfied. Barbed wire entered the design after Casey came upon a piece of it in the woods.

Once the bird and the fence post were established, he developed the field of snow, an even, warm mixture of white and Naples yellow, with touches of Vandyke brown, yellow ochre, and charcoal gray. The results pleased him. Says Casey: "There is something eloquent in the pairings of nature—of that bright, robust bird setting beautifully into a simple landscape of snow and grasses."

Originally, Casey had a tree stump, some rocks, and dead leaves in the painting, with the pheasant in the middle. "I knew right away I didn't want it there," recalls the artist, who repositioned the bird off-center, in the upper right section of the panel. Realizing other elements weren't working, he pared down the painting to bird and grasses, later adding a fence post for balance.

Building Up Rich Color

Robert K. Abbett

Benjamin Franklin nominated the wild turkey as America's national bird and artist Robert Abbett knows why. Typically, these birds often convey tints of red, white, and blue on their heads and necks. But getting the turkeys' unique body sheen correct is the major challenge in painting them. "Iridescence isn't explained by anything we know in light or physics," says Abbett. "It's a form of color that has no reason for being." After years of observing wild turkeys, in pens at his Connecticut farmhouse and in the woods, he has learned some of the secrets to painting them successfully.

The surface that faces the viewer most squarely appears to carry a greenish sheen, whereas the feathers curving away, top and bottom, take on a reddish cast. But it takes form as well as iridescence to capture the look of a wild turkey. "They are shaped like a football with a head and tail," notes Abbett, "and they have distinctive big round wing feathers, just above the striped flight feathers, which curve beyond the curve of the bird itself. Out in the woods, their unique shape identifies wild turkeys many yards away."

Abbett first drew the scene in pencil on a gessoed board and inked it in. He then smeared the surface with a khaki-colored turpentine wash to create a neutral mid-value tone, from which he worked toward both the lighter and darker passages. "It's hard to come up with a disharmonious color when painting over an underpainting," says Abbett. "Every color becomes a cousin because each one takes on a bit of the khaki cast."

The rocks were first built up to a granular texture with modeling paste, an acrylic medium mixed with marble dust that dries matte and opaque, followed by a wash of khaki-toned color. Once that was dry, Abbett scumbled a light gray across the top. He then went back in with reddish-grays and greenish-grays, filling in the shadows with a cooler gray mixed with some blue and finishing with blotches of bluish-gray lichen.

Many of the woods colors are browns leaning toward reds. Since red and green are complementary, the combination of over- and underpainting sets up a rich vibration. Says Abbett: "As a colorist, I have to keep in mind how to make the colors luxurious and mysterious. Just painting the background gray, with grayer shadows, would have been boring." Green also lurks beneath the fallen leaves, coming through in spots. The brightest leaves, in the sunlight, are shown in two different tones: a pinkish color, composed of burnt sienna and white, and a slightly darker yellow-orange. The leaves in shadow are a grayish-brown tone.

Abbett generally works back to front, bringing all areas along at the same time. Whenever something starts to predominate unnecessarily, he grays it, makes it darker, or simplifies it—painting back and forth, from light to dark and sharp to fuzzy, until it blends again. "If you are going to have some rough areas, put them down first," he says. "Paintings always get tighter, never looser. Once you lay in too much detail, it's tough to pull it back." *Autumn Monarch— Wild Turkey* was commissioned in 1982 for the Wild Turkey Federation stamp and print program, to help raise funds for the conservation of these stately birds.

AUTUMN MONARCH—WILD TURKEY
1982, oil, 28⅝" × 21" (72.7 × 53.3 cm).

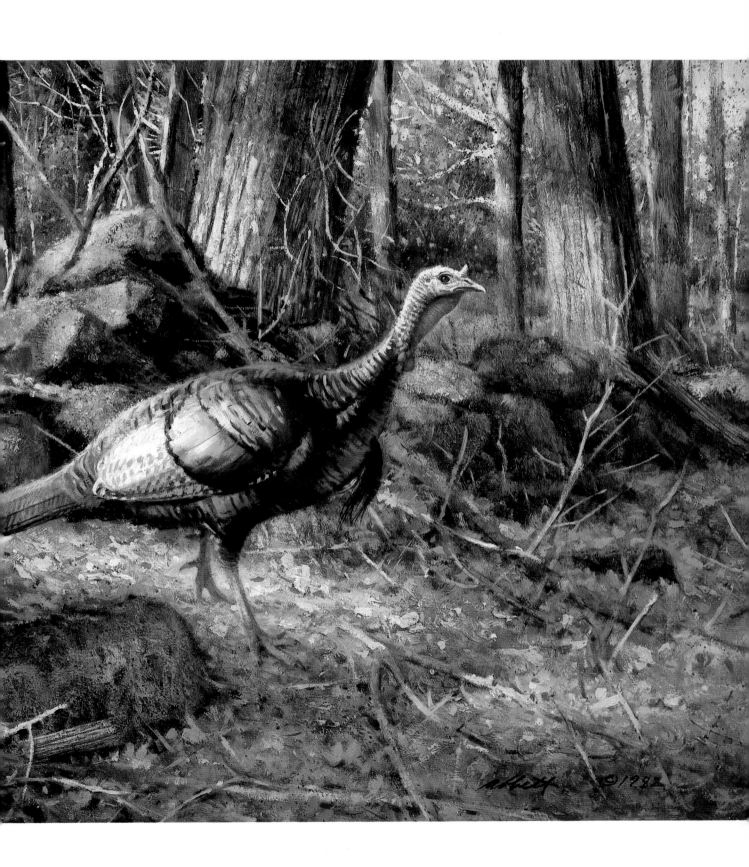

Suggesting Rapid Movement
Raymond Harris-Ching

An unfinished partridge study, published in color here for the first time, clearly shows Harris-Ching's technique of rendering his subjects from beak to tail. All the elements are painted simultaneously as the artist works down the paper—very little overpainting or reworking is ever necessary.

Late one afternoon, wildlife artist Raymond Harris-Ching was searching through some brush near his home in Sussex, England, when a partridge, startled from cover, rose up before him and whirred off, powered by quick beats of its short wings. The concentrated burst of energy impressed the artist as something worth painting. He wired a dead specimen into position in the studio and worked on it over a period of several days. It is painted slightly under life-size, which is unusual for the artist.

Harris-Ching began with a finely detailed pencil drawing over a smoothly sanded gessoed ground, on a small Masonite panel. The drawing was sealed from smudging by a thin layer of pale ochre-colored acrylic paint. After letting the surface dry for a day, the artist rendered the partridge in oils, laid down in layers as transparent as watercolor. As with all his paintings, he worked from top to bottom, painting the bird primarily in earth tones. Says the artist: "It was not until I laid in the clean, sharp burnt sienna mixture on the tail feathers that the picture finally came alive."

The loose feathers were added to suggest that the partridge may have snagged itself on a bramble in its haste to escape. The fact that they are falling serves to reinforce the upward thrust of the bird. The feathers may appear softer, but they are rendered with the same exacting detail as the bird itself. "I don't blur my edges, I don't make anything up. They're there as much as anything else is there," says Harris-Ching, adding, "If you look at a feather closely you will be fascinated and intrigued. At the time I painted these, all I wanted to do in the world was draw those little feathers. It's the key to everything I do."

STARTLED PARTRIDGE
1976, oil, 16" × 19" (40.6 × 48.2 cm).

Leading the Eye
Robert K. Abbett

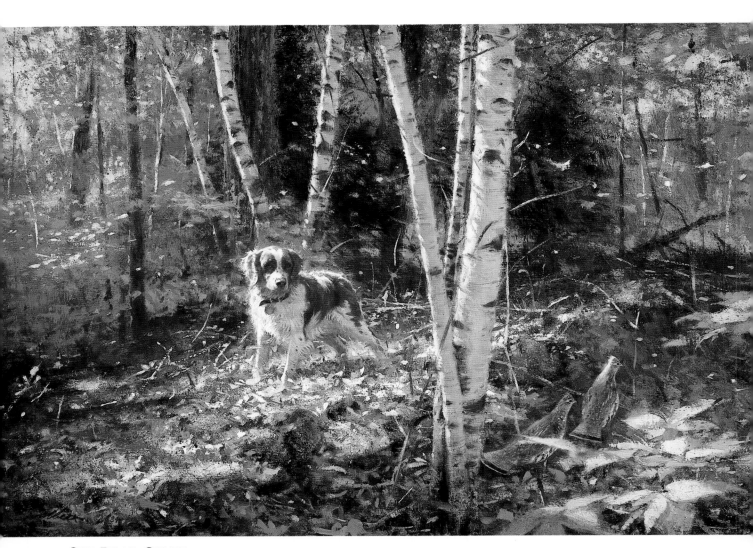

OLD ROAD COVER
1984, oil, 30" × 20" (76.2 × 50.8 cm).

The artist is also a stage director, selecting and arranging elements to lead the viewer's eye through a painting. If successful, the picture includes all that needs to be seen to understand the story, without disturbing the natural order of things. In *Old Road Cover*, a Brittany spaniel has just "pointed" two ruffed grouse, partially hidden beside a stone wall bordering an abandoned logging road.

The viewer himself follows the dog's stare to spot the two birds, then traces the road back into the painting. Areas of sharp contrast, such as the bright white of the dog, the birch trees, and the patch of sunlight on the leading bird's head, also hold attention.

"You want to do anything you can to engage the viewer," says artist Robert Abbett. "So you coax with visual tricks."

The color scheme of *Old Road Cover*—gold and gray—is one of Abbett's favorites. After laying in an overall khaki tone to unify the picture, he began putting down the lightest lights and darkest darks. If the artist knows something is going to be white or near-white, such as the spaniel and the birch trees, he puts it in first, then works against it. "Many artists think white is something that comes last, like dessert, to bring the whole thing to life," he says, "but it destroys the piece instead because the artist has unwittingly already painted a well-balanced picture without it." Abbett uses regular white oil paint for white subjects and highlights, with a thicker underpainting white to enhance textures as needed.

As he paints, Abbett is aware of how the colors spill back and forth, as on the birch tree on the right which picks up a warm reflection halfway up and then gets cooler at the top. The lower right of the picture was a troublesome area. At first, the artist put in too many leaves and stones and the details came flying forward. When he finally smeared the area with a large brush, it dropped back into place.

Abbett is well-known for his paintings of sporting dogs. He finds that it adds to the movement of a painting if the animal is facing away from, and turning back toward, whatever it is looking at—a device that also helps to telescope the space. If the dog were staring straight ahead, it would string out the picture twice as far.

In Yankee Drummer, *one of Abbett's earliest paintings, the strong diagonals of the log lead the viewer's eye into the painting and the blurred wing action of the displaying male grouse holds our attention. To convey the quality of the rotting log, the artist built up texture with thick paint, then added local color, scumbling his brush across the dried surface to pick up the tops of the bumps for a three-dimensional effect.*

YANKEE DRUMMER
1970, acrylic, 24" × 18" (60.9 × 45.7 cm).

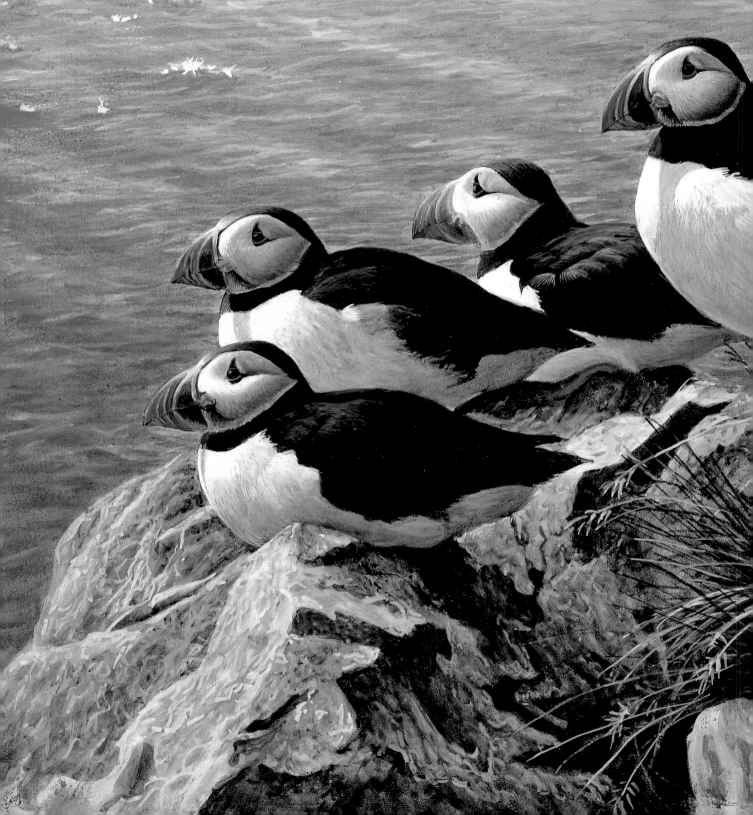

Wanderers of the
Sea and Shore

© Robert Bateman.

Warming Seascapes with Glaze
Keith Shackleton

AROUND THE SHAG ROCKS:
LIGHT-MANTLED SOOTY ALBATROSSES
1979, oil, 30" × 48" (76.2 × 121.9 cm).

The gale has blown out and the swell is settling. Some light-mantled sooty albatrosses circle listlessly against the dramatic pinnacles known as the Shag Rocks, which stand out of the open ocean about 140 nautical miles west northwest of South Georgia, in the South Atlantic.

Artist Keith Shackleton first drew the scene in charcoal, to establish the principal shapes and directions of movement. Shape is more important than color here, and he spent considerable time rearranging the grouping. There were more albatrosses in the early stages, which he eliminated one-by-one, separating the remaining four birds and altering the position of the rocks for a more pleasing composition.

With a wingspan of about eight feet, the light-mantled sooty albatross is among the smaller of the albatrosses—known as "mollymawks" to early sailors. This species has the most extreme ratio of wingspan to depth of any bird in the world, resulting in highly efficient soaring flight. The birds can glide for hours on stiff wings, seldom flapping, as they follow the contours of the sea, taking advantage of the updraft caused by the wave shapes.

The nearest albatross, painted first because of its obvious dominance, is directly in front of the sun and shown in virtual silhouette. "The thing is to get the tone of it right so that it's still a very dark brown bird but doesn't look black," says the artist. The base color of its body is mostly burnt umber, stiffened with a bit of blue and crimson, then glazed with brown pink, a pigment actually a transparent deep gold in color. The bird's top surface, as well as the other birds, contains the same colors, with a lot more white.

Shackleton made up the sea. "Because water is a free agent and completely flexible, you can create your own mountains of sea, and then light it yourself," he says. "It will do your bidding provided you respect the character of the thing." Its base color is a pearly gray, made up of various blues, with a bit of cadmium orange and burnt umber. Alizarin crimson with blue produced the mauve areas.

Little dark marks on the near side and light bits on the shiny side of the ripples created the accents. Shackleton finds accents handy, positioning them so that the brightest lights were behind the bird, putting its profile in high contrast. The pale golden light throughout was achieved with an overall glaze of brown pink, consisting of a tiny bit of the pigment in a lot of medium. Shackleton uses the color often to warm seascapes such as this, applying it like a thin finishing varnish.

Shackleton worked out the positions of the birds in relation to the rocks with sketches.

Painting the Sea

Keith Shackleton

"There is nothing that can hold the eye and the attention longer and more "restfully than the ocean," says artist-explorer Keith Shackleton, "which explains why I paint so many pictures like this. The scene produces something akin to a conditioned reflex. An albatross will slide down the trough of a wave, vault upward into the wind, and catch the last horizontal rays of a setting sun. On every occasion it is as if I were seeing it for the first time; the reflex is to get out the brushes and paint." The Drake Passage is off Cape Horn, at the southernmost tip of South America, where currents and wind converge to produce the worst weather in the world. Here, a force-ten gale, packing winds of sixty miles an hour, creates a heavy sea, with forty-foot-high waves. The view here is at Christmastime—summer in the Southern Hemisphere—with the temperature at about 32 degrees F and the sun still above the horizon, even though the hour is late.

Shackleton has studied the sea for so many years that it has stuck in his mind, and he doesn't have to do many seascape sketches anymore. "The sea is basically a progression of hills moving along, which have been created by the wind, and you can work out for yourself just how you want to portray it," says the artist. "All you need to do is design your own little set of hills and then work out the direction of the wind. The side facing the wind is more gentle than the other side, but swifter, running over the top and causing the wave to break." When the groundwork is done, Shackleton overlays the surface effects—streaks and stripes of foam, and breaking waves with banners of spray flying.

Shackleton completed the main water masses and sky first, then the bird. In evening light, shadows become stronger and light, by contrast, is lighter. Consequently, the artist has used darker blues, including plenty of indigo, with alizarin crimson and cadmium orange to take the aggressive blueness out of it. At the top of a wave, where the water becomes thin and takes on a glassy look, Shackleton used Winsor green—"which really ought to be sold with a license, it's so horrible" he says—killed with a bit of alizarin crimson and buried with Antwerp blue and a lot of white, to achieve an opalescent effect.

The foam contains all the same colors. In general, white water is warmer-hued than the sea itself. Shackleton warms up shadows cast on foam with a bit more crimson, or brown-pink—actually a transparent deep gold color—which he uses mixed with a lot of medium.

The single wandering albatross, commonly seen in the Drake, is a typical and important constituent of any seascape of the southern ocean. Here, its position is critical to the picture.

A small color sketch, made on-the-spot, captures the rhythms of the sea.

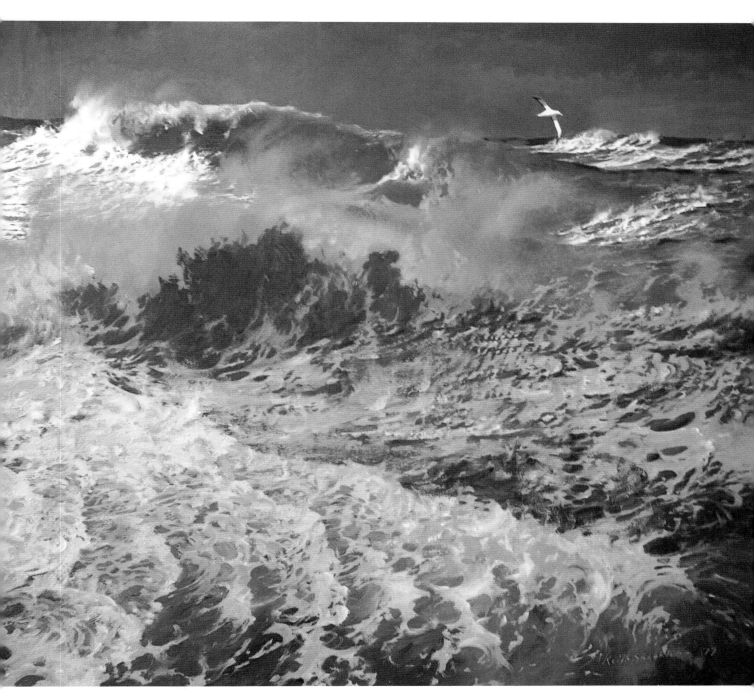

EVENING: DRAKE PASSAGE
1977, oil, 36" × 24" (91.4 × 60.9 cm).

The Importance of
Accurate Field Sketches

Keith Brockie

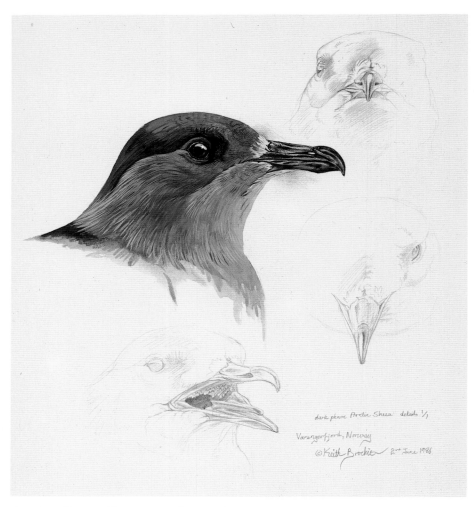

ARCTIC SKUA, (PARASITIC JAEGER)
1986, watercolor and pencil, 6½" × 7" (17 × 18 cm).

Knowing he has accurate reference drawings at his disposal gives Keith Brockie more confidence to sketch quickly in the field. "You can get the general impression of a bird and not have to bother with the fine details," the artist explains. "You've got the backup when you need it." In this case, an arctic skua, found on an island in Norway with a broken wing, provided the opportunity for a head study.

Skuas, also known as jaegers, are large gull-like birds that range widely over the North Atlantic. They feed on shrimp, fish, and rodents, and also prey on the eggs and young of seabird colonies.

Brockie drew the skua life-size, using a pair of dividers to insure accurate one-to-one measurements. He was particularly interested in the skua's complex bill, which he sketched from various angles, and in the color of its reddish gape, which, along with its other soft parts, would discolor quickly after death.

When sketching a head-on portrait for reference, Brockie often completes just half, leaving the other side unfinished. That way he records the detail he needs, in much less time. "It also makes it easier to get the correct balance," he explains. "Often, if you start on the other half, the features will become uneven." If the artist does fill in

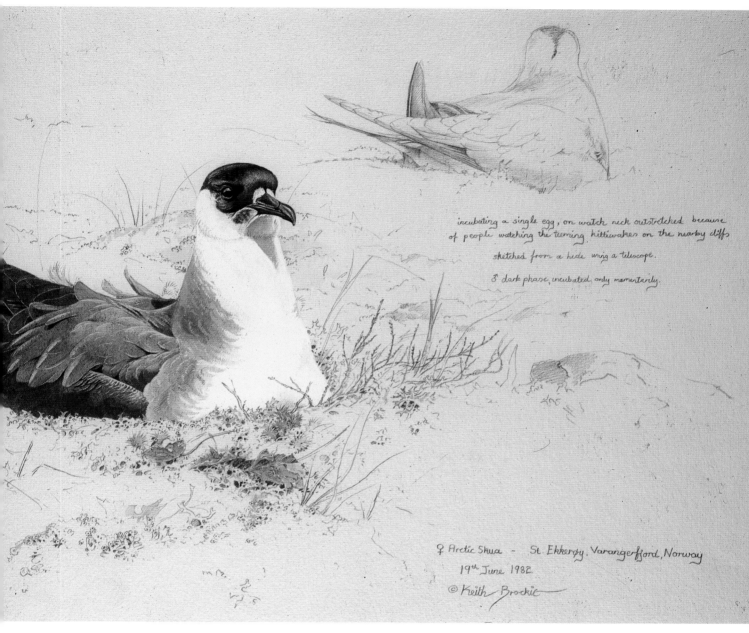

incubating a single egg, on watch neck outstretched because
of people watching the teeming kittiwakes on the nearby cliffs

sketched from a hide using a telescope.

♂ dark phase, incubated only momentarily.

♀ Arctic Skua - St. Ekkerøy, Varangerfjord, Norway
19ᵗʰ June 1982
© Keith Brockie

ARCTIC SKUA, *Pale Phase*
1982, watercolor, 19½″ × 14″ (50 × 36 cm).

the other side, he uses a pencil and ruler to line up the features. When he wants to highlight a small white area on a dark subject, such as the patch of feathers above the skua's bill, he often starts with a colored base, later over-painting the white areas with opaque gouache. Here, the skua's head was painted with a mixture of raw umber and burnt umber over an ochreous wash. Lamp black provided the darker tones, with light streaks added in Naples yellow.

The skua, also known as the parasitic jaeger, comes in two color phases: dark and pale. Brockie came upon this pale phase arctic skua on the tundra, incubating a single egg. Here, the artist selected colored paper to offset the skua's bright white neck and breast. He sketched the bird from a canvas blind, about twenty-five yards away, with the aid of a telescope. The bird's back is rendered in a raw umber wash, with burnt umber added for the wings. Its neck and breast are zinc white, overpainted with a bolder opaque white. The zinc white also is diffused into its flanks.

Brockie enjoys finding details that capture the individuality of each bird. In this case, several of the skua's back feathers, lifting in the wind, add freshness to the work. The drawings offer an interesting comparison between dark and pale phase plumages of the same bird.

The Art of Camouflage
Richard Casey

e had come for a walk along the cobble beach near his home on Swans Island, Maine. The wind had picked up, driving the waves harder, and at the shore there was the persistent rumble of stones being dragged into the sea and shuffled. Richard Casey found a spot out of the breeze and began to draw. At once, a small bird flew by on arched wings, calling "killdeer! killdeer!" and dropped down quickly among the stones. Casey stood up, trying to calculate where the bird had landed but "it was as if it had merged into the stones themselves," the artist recalls. As he walked closer, the startled killdeer flew up again, becoming visible briefly before disappearing among the stones once more.

The subject proved irresistible. Casey framed a section of the cobble beach and placed the bird in a central position. It was already so well camouflaged that he didn't have to hide it further. After blocking in the rocks with pale washes of a creamy mixture, altered with charcoal gray and raw umber to establish the pattern of gray and brown stones, he began to glaze, using very thin washes of pure pigment to add a hint of color here, a few speckles of black there, giving the rocks form. "I went back and forth so many times I can't remember," he says. Casey wanted the landscape complex and realistic, to capture the ability of the killdeer to blend with its environment. Working all over the panel from light to dark, in varying strengths, he built up the scene with opaque Naples yellow, yellow ochre, raw and burnt sienna, and burnt umber, glazed with pure yellow ochre, burnt sienna, and burnt umber. "It was an organic process, a matter of color harmonies and fusing the picture into one working whole, with everything equally laid in," the artist explains. Shadows between the stones were painted last, with a glaze of alizarin brown madder. Barnacles were added with a mixture of white, Naples yellow, and a touch of ultramarine blue.

The killdeer is the same basic colors as the rocks—charcoal gray and raw umber—plus a touch of Naples yellow to give it a warmer cast. In fact, Casey had to fight a tendency to make it too similar to the rocks. At one time he had the bird so well camouflaged that viewers couldn't see it at all, even when they examined the painting up close. But that wasn't the point, Casey decided. He wanted the bird to blend in yet be completely defined.

The sandy bar at the top of the painting is as important as the intricate pattern of stones below it, distracting the eye just enough. Although there are some shadows among the rocks, the light is diffuse. "If everything had been cast in shadows it would have been too complicated, which would have defeated the purpose," says Casey. The result is a landscape with a killdeer—visible but invisible—just as it appears in nature.

KILLDEER! KILLDEER!
1984, oil, 48" × 28" (121.9 × 71.1 cm).

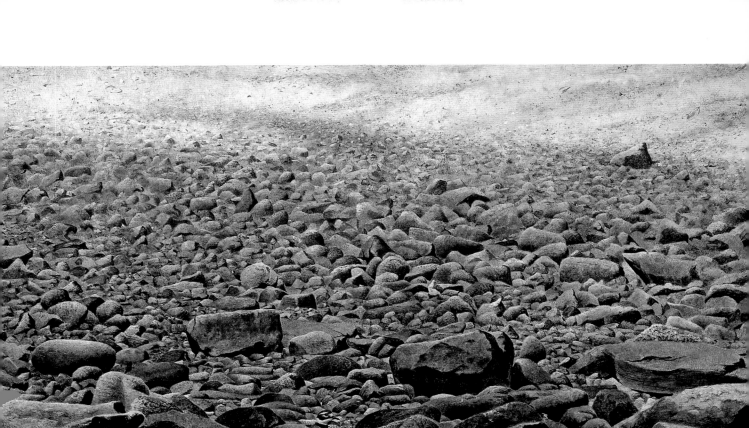

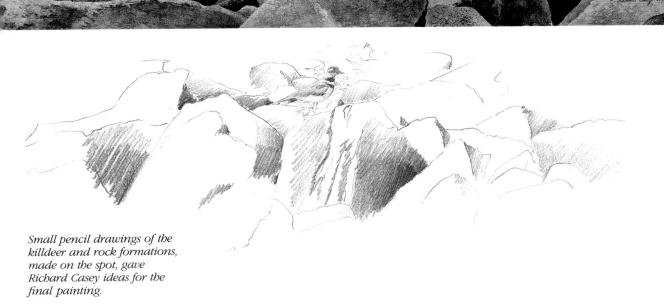

Small pencil drawings of the killdeer and rock formations, made on the spot, gave Richard Casey ideas for the final painting.

Painting Birds Through a Telescope
Keith Brockie

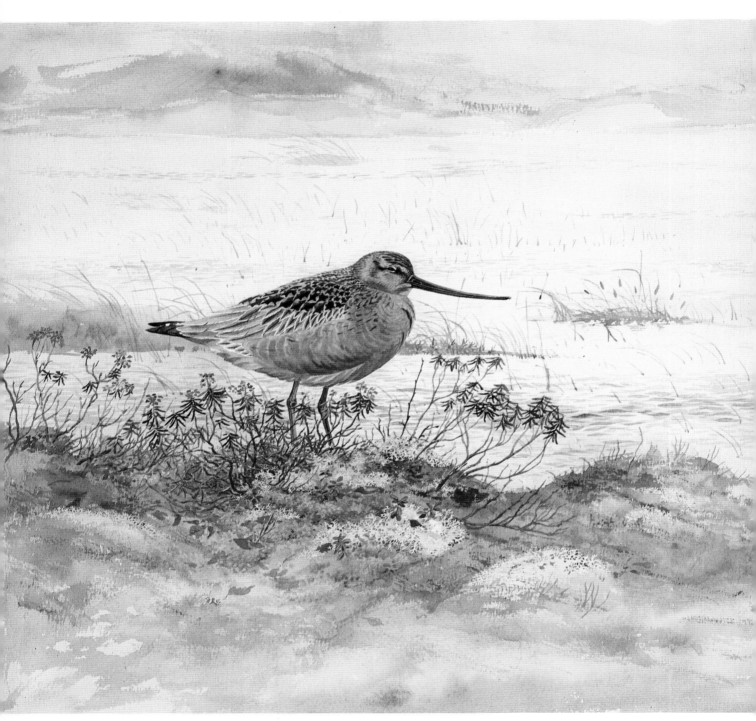

MALE BAR-TAILED GODWIT
1986, watercolor, 19" × 14" (48 × 36 cm).

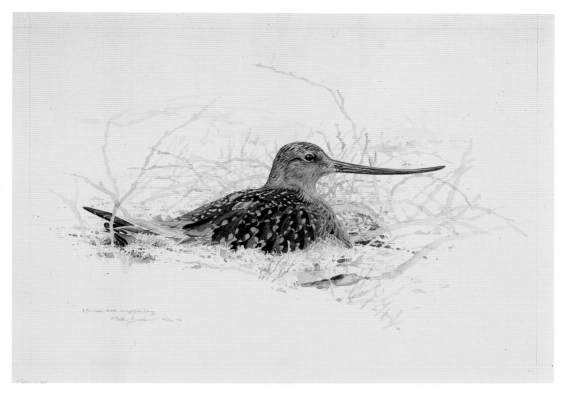

INCUBATING MALE BAR-TAILED GODWIT
1986, watercolor, 15" × 10½" (39 × 26.5 cm).

In their breeding plumage, bar-tailed godwits are among the most splendid of the sandpiper clan. But unless one travels to the High Arctic in May or June, the chances of seeing the rufous-colored birds are slim. Godwits, much larger than most sandpipers, are more commonly found in drab winter plumage, along the coasts of North America and Europe.

Artist Keith Brockie found this nesting male incubating a clutch of eggs among dwarf birch on the tundra plateau during a trip to North Norway. He sketched the bird from a canvas blind, which he was able to move gradually closer until he was within fifteen yards—ideal telescope range. He studied his subject for several hours, committing its features to memory while observing it through a 30 × 75 power close-focus telescope, mounted on a tripod. The godwit made an ideal subject. In all that time, it moved just twice to turn the eggs, occasionally flattening itself when predators flew by.

Brockie started with a quick pencil drawing, but when he realized the bird would remain still, he added more and more detail and then finally started to paint on the spot. Working from light to dark, the artist began with the godwit's head and a few feather tracts, then painted its neck, breast, and spangles in burnt sienna, with touches of yellow ochre. The dark back feathers were done with washes of raw umber and burnt umber, darkened a bit with lamp black. He was careful to include two grayish feathers, retained from its winter plumage. The day was bright but slightly overcast, with no shadows. Inside the blind, however, the light was dim. Brockie decided to finish the piece in his camper, in better light, with the help of plumage notes.

On the same trip, the artist came across another male bar-tailed godwit by a roadside pool. It was a cold, blustery day with occasional showers of sleet, and the bird was hunched against the elements, eyes half-closed. This time, Brockie used his camper as a blind, mounting the telescope on the window. He sketched the bird directly onto a watercolor block, placing his subject to the left of the picture to emphasize the strong wind. He used burnt sienna for its plumage, applying progressively darker washes, mixed with burnt umber, in a circular pattern to convey the bird's puffed-out shape. A mixture of raw umber, burnt umber, burnt sienna, and sap green make up the foreground. The water was rendered in Payne's gray, to reflect the color of the overcast sky.

Emphasizing the Subject
Keith Brockie

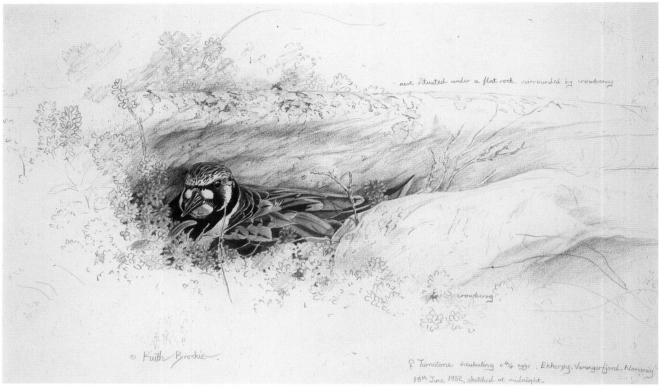

RUDDY TURNSTONE, *Incubating Male*
1986, watercolor, 11½" × 15½" (29 × 40 cm).

The ruddy turnstone, a sandpiper found along coast-lines in the fall and winter, is one of the most common birds on the tundra in summer. It nests in a variety of situations, including out in the open, where it relies on its contrasting tri-colored plumage for concealment. "It's magical how they can blend so well with their surroundings," says artist Keith Brockie, who painted these birds on a tundra plateau in Norway. Both sexes tend the eggs.

The more brightly colored of the two, a male, was painted at midday from the artist's camper, just ten yards away. As with most of Brockie's paintings, the composition was dictated by his view through the telescope. The artist started with the turnstone, almost finished the background, then went back to complete the bird. He laid in the main feather tracts first, using burnt sienna and lamp black. The turnstone remained still throughout, enabling the artist to establish a sense of intimacy with it, which produced a more relaxed painting. Yet Brockie was careful to convey the alertness in the bird's eye—ever watchful for the first sign of danger.

In the process of painting the turnstone, Brockie inadvertently saved its eggs from being flattened by an oncoming herd of reindeer, which split on either side of his parked camper, missing the nest by less than a yard.

To focus attention on the turnstone, Brockie kept the background relatively simple and diffused, using some of the same colors on the bird and among the rocks, to tie the two together. "I didn't want to do too much to the painting," he says. The result is midway between a field sketch and a finished work.

In summer on the tundra, the sun is out twenty-four hours a day. The painting of a drab-colored female turnstone was done at midnight, the only time the sun was low enough to illuminate its nesting spot under a stone. Brockie worked from a canvas blind near the nest, using binoculars. There wasn't enough light to rely on watercolors, so he worked mainly in colored pencil. "Each turnstone painting was an experience," says the artist, noting the differences in sex, plumage, background, and light. "I enjoyed doing them both immensely."

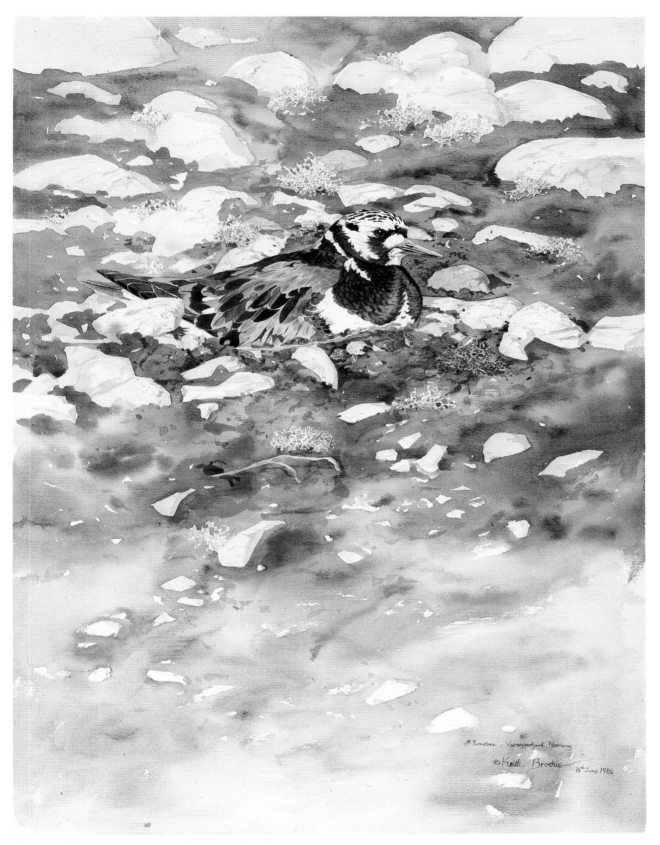

RUDDY TURNSTONE, *Incubating Female*
1982, watercolor and colored pencil crayon, 14" × 8½" (36 × 22 cm).

Capturing Icy Solitude

Keith Shackleton

The scene is a midsummer evening, on a short neck of the Antarctic peninsula known as the Graham Coast. A single living thing—a snow petrel—strikes a white accent against the forbidding icescape. Keith Shackleton has experienced the cold reaches of the Southern Hemisphere many times, as artist-naturalist on board the adventure ship *Lindblad Explorer*. These vistas are among his favorites.

"Man played no part whatsoever in the molding of this scene," Shackleton writes. "Every shape and every line is the combined product of inexorable natural forces and the passage of time. It is a wilderness that is complete in every aspect and connotation of the word. Only a short walk on the moon might offer something more harsh, more unwelcoming. A landscape like this, savage, hostile, and unremitting though it may be, by aesthetic standards, is still the most intrinsically beautiful landscape of all."

The scene is much as the artist saw it on that calm, sunny eve. As usual, Shackleton did a few sketches on the spot, then later worked out the drawing on the panel in charcoal. The precipitous ice foot was painted first. In it can be found the wide range of blues the artist uses for polar subjects: indigo, the color of dead ink; cobalt; electric-bright Antwerp; and the even fiercer Winsor blue. Most of the blues can be found everywhere else in the painting as well,

their tones altered by varying amounts of white. To take the cold edge off the blues and lessen their intensity, he adds touches of alizarin crimson and cadmium orange.

The paint is put straight on, with no glazing, using long-handled Winsor & Newton brushes. Occasionally, Shackleton finds a palette knife useful for creating sharp, strong lines, but more often he achieves gradations by rubbing the surface of the paint with his thumb. Here, he painted the most dominant shapes first—the ice foot and snowfield, with its strong horizontal lines, then the foreground iceberg, followed by the monochromatic pattern of rocks and ice in the background. "Light is important when painting ice," says Shackleton, "because only that betrays its shape. It is also translucent and therefore can appear luminous—a very different proposition to the white chalk cliffs of Dover."

Snow petrels are roughly the size of pigeons but more graceful, with longer wings and more "dash," says the artist. He drew the bird on a piece of paper at the size he felt it should be, then moved it around the surface until he found the right spot. "If there is just one bird in a composition, it may only be a small thing but the position of it is mighty significant," he notes. The petrel's startling pure white is an extension in miniature of the white curve of the snow-capped ice foot.

As usual, Shackleton did some little sketches on the spot, then later worked out the drawing on the panel in charcoal.

ON THE GRAHAM COAST: SNOW PETREL
1984, oil, 40" × 30" (101.6 × 76.2 cm).

Jungle Birds

Working from Quick Color Studies
Lawrence B. McQueen

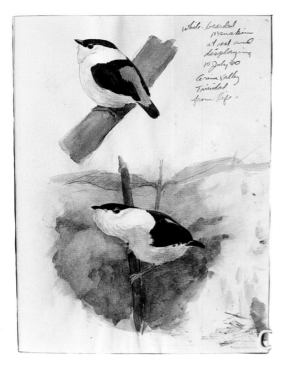

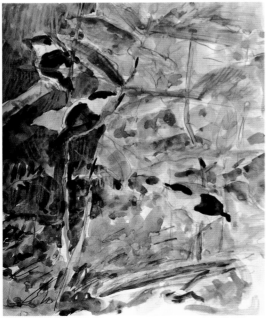

McQueen found these manakins in Trinidad, and made several quick color studies (top) on the spot. Back at his studio, he roughed out an idea sketch (bottom) and began the painting.

Hardly pausing for a moment, white-bearded manakins zip about explosively in their lek—a small courtship area on the floor of a tropical forest in Trinidad. The males' throats puff out in display and their wings are specialized to make a loud snapping sound.

Until artist Larry McQueen's eyes adjusted to the dim light, all he could see as the birds flashed past were their white parts and vermilion feet. The black portions were lost in the surrounding woods. The manakins, as small and robust as chickadees, were quite tame, and behaved as though the artist were part of the terrain. He quickly roughed out some sketches of the birds, and made sketches and photographs of the vegetation, but not fast enough to avoid being bitten by hundreds of chiggers.

The preliminary sketch of the composition is the same size as the final painting—unusual for McQueen who normally makes idea sketches much smaller. But here he wanted to show the birds life-size. "As I am working on a bird, I have a better feeling for it if it is actual size," he explains. "If a bird is smaller than that, you have the sense that it's off in the distance and not that accessible. And when there is atmosphere in front of it and you don't see it quite as clearly, it gives a different impression."

The entire painting is done in transparent watercolor, worked from light to dark. The manakins are primarily Winsor & Newton's neutral-tint mixed, with indigo; the pure neutral tint shows on their rumps. Their feet are Winsor red over yellow; the white parts are raw paper, detailed lightly with neutral tint. All of the greens in the painting were mixed and toned down with warm colors: vermilion, burnt sienna, violet, and red. The upper-right corner of the painting presented a problem. McQueen didn't want this area to continue too far back in space, nor did he want to call attention to it with too much detail. After several attempts he finally rubbed it out with a wet paper towel, and let it stand as a screen of vegetation.

For most of his watercolor paintings, McQueen uses a cold-press, 140-pound, all-rag paper with just enough tooth to catch the pigment. Fabriano Artistico is a favorite for its brightness and ability to withstand rub-outs, erasing, and masking. With very large paintings, McQueen uses Arches' paper, which he often stretches on stretcher bars, like a canvas. He prefers brushes that are firm, hold a lot of paint, and come to an absolute point, such as Winsor & Newton Series 7. Often he will start a painting with a number 10 or 12 size, then pick up brushes of progressively smaller size, down to a number 4, as detail increases.

WHITE-BEARDED MANAKIN
1980, watercolor, 14" × 19.5" (35.5 × 49.5 cm).

Using Airbrush to Suggest Distant Foliage

John P. O'Neill

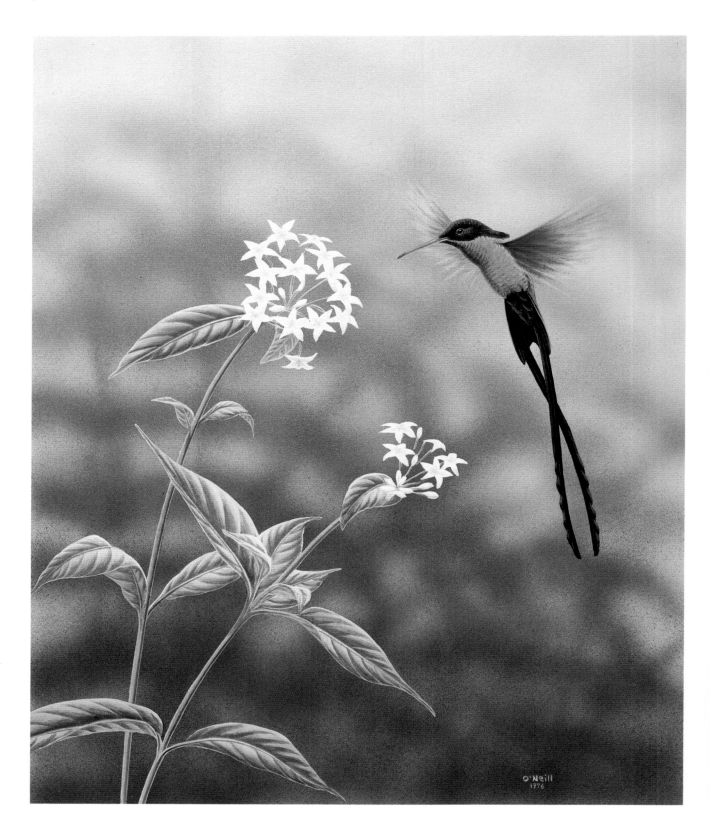

Perhaps because of his years in the field, artist-naturalist John O'Neill prefers to paint birds in sharp focus against diffused backgrounds, not unlike the effect of looking at them through binoculars. Although he now wields brushes and sponges to achieve the illusion, in the paintings shown here the artist used an airbrush and acrylic paints, spraying the colors across the surface after masking out the birds and foliage.

The background in *Streamer-Tailed Hummingbird* was handled unevenly, with some areas darker than others, to create the effect of light bouncing off leaves. The out-of-focus limbs behind the channel-billed toucan were created with a more linear technique. In both paintings, the first layer was a light and transparent mixture of cerulean blue and white. Sap green, burnt umber, and a bit of black provided the darker tones. For sunlit highlights, O'Neill then went back with accents of sap green and yellow.

O'Neill mixed his acrylic colors in a small jar, grinding the thick paint together with the bristles of an old brush while slowly adding water until the mixture reached a creamy consistency. Shaking it will only add air bubbles, the artist warns. To remove the finest particles he poured the paint through a piece of pantyhose, stretched across the top of the mixing jar, into 35mm film canisters. The filtered paint was then ready to be poured into the small bottles that attach to the airbrush.

O'Neill surrounded the area to be sprayed with brown paper and wore a filter mask to avoid inhaling airborne paint particles. "Once the airbrush starts, you need to keep it constantly in motion," he notes, "or paint will build up in one spot." Fast motion results in less paint in any one area and fuzzier edges, creating the illusion of greater distance. Slower motion makes the edges sharper and brings the objects closer. The greater the air pressure, the finer the particles and resultant spray. Distance from the paper also affects the results. O'Neill works eight to twelve inches from the surface, adjusting the nozzle midway between a fine and a wide spray.

After the background of each painting was complete, the artist painted the birds and foreground foliage in opaque layers of gouache and watercolor. To create the effect of iridescence on the hummingbird, a Jamaican species, he laid permanent light green next to almost black shadows, the contrast giving the green a heightened brilliancy. Highlights are medium azo yellow. The wings of the hummingbird, blurred to show motion, are lamp black. Its bill is cadmium red, with a touch of cadmium orange.

Unlike the hummingbird's plumage, toucan feathers have a particularly soft appearance and reflect little light. To capture that effect, O'Neill painted the bird in velvety lamp black gouache, washing lightly over the lamp black and Naples yellow highlights with raw umber watercolor, for an even softer look. The toucan's breast is medium cadmium orange and cadmium yellow, fading to white, its rump flame red, textured with red mixed with Payne's gray. The facial skin is cerulean blue with a bit of turquoise, mixed with white.

CHANNEL-BILLED TOUCAN
1976, acrylic, gouache, watercolor, 20" × 25" (50.8 × 63.5 cm).

STREAMER-TAILED HUMMINGBIRD
1976, acrylic, gouache, watercolor, 12" × 18" (30.4 × 45.7 cm).

Capturing Iridescence

John P. O'Neill

The spectacular golden-headed quetzal is found near the ruins of Machu Picchu, in Peru. Artist John O'Neill, who has birded around the ruins many times, thought the quetzal's gaudy plumage and the grandeur of the scene would complement each other nicely in a painting. Here, a pair of quetzals—the male sitting quietly, his mate flying off—are shown on a cool misty morning in the mountains. "Atahualpa was the last Inca, and I'm sure he would be proud to be reincarnated as a splendid male quetzal," says the artist, referring to the title of the work. He used study skins for plumage details and photographs of netted birds, hand-held.

O'Neill captured the quetzal's brilliant iridescence by keeping the colors clean and transparent, and by making the shadows very dark—in some cases black. "Putting little dark marks to indicate plumage texture in with the transparent colors makes them look shiny and bright. The problem is being bold enough to do it," he notes. For the body colors, the artist used thin glazes of acrylic, which dries hard and doesn't lift up to mix with subsequent washes.

The iridescent green on the quetzals' head and back was achieved by glazing transparent layers of phthalo yellow-green, permanent green light, and azo yellow over shadows of Payne's gray accented with black. To get the bronzy sheen, the artist applied a thin glaze of cadmium orange over green. The male's bright red breast consists of cadmium red medium washed over body shadows of Payne's gray and napthol crimson. "The trick to red is keeping it transparent. Don't let it get too muddy," says O'Neill. "There are so many different reds—too much yellow or orange in the highlighted areas will change the total effect." O'Neill wanted the tail and outer wing feathers "dead flat" in texture, and so used black gouache, with highlights of Naples yellow. The most brilliant accents in the iridescent areas, added at the very last, were made by washing thin glazes of color over texture that had been added in pure white gesso.

Another means of obtaining iridescence, particularly effective when painting a hummingbird's throat patch, for example, is by placing two intense colors side-by-side. When the center of each feather is blue, surrounded by red, the eye combines the colors to get purple. Similarly, golden orange feathers edged with deep red yield bright iridescent red. Since most iridescence results from light bouncing off the feathers, rather than their pigment, the color depends on the angle of viewing. The curved throat of a hummingbird appears almost black in certain lights. Painting the edge of the dark patch bright orange, fading to red, will convey the iridescent gorget of a ruby-throated hummingbird. The color of reflected light—light on the side away from the sun—is often unexpected. With bright green iridescent birds, the reflected light is bright blue. Iridescent orange may reflect deep blue on the shadowed side, which O'Neill renders in cobalt or cerulean.

REINCARNATION OF ATAHUALPA
GOLDEN-HEADED QUETZAL
1986, acrylic, gouache, watercolor, 30" × 40"
(76.2 × 101.6 cm).

© John P. O'Neill 1986

Recreating a Mossy Cloud Forest

John P. O'Neill

Artist John O'Neill is one of just a handful of people who have seen this rare tanager. The bird inhabits a small area of the cloud forest on the eastern slopes of the Peruvian Andes, a region O'Neill has visited many times on research expeditions. "Being in a cloud forest is exciting," he says. "The mist can cause even the most mundane moss-covered tree to appear mysterious and enchanted. Sometimes it's so quiet that a single drop of water falling seems loud. When a flock of birds comes through there is chaos and pandemonium, then they move on and all is silent again."

One day O'Neill spotted the pair of tanagers hopping quietly along some mossy limbs, probing for insects. He observed them for a long time. Back in his studio, he recreated the scene, using photographs, study skins, and his own recollections. After transferring the drawings and masking out the birds and prominent limbs, he painted the background first, using hard-drying, waterproof acrylics. The areas of distant light were washed with Liquitex's neutral-gray, value 9 acrylic—O'Neill's favorite "fog" gray.

Next came the mossy limbs, a complicated process of bringing up details, knocking them back and then re-defining them. O'Neill built up the moss from a dark brown base of raw umber, sap green, and black acrylic to make it look like it was growing as a thick mat on the limb. Some of the color also was extended downward from the bottom of the branch to indicate hanging roots and debris. The upper half was then dabbed with a moss green acrylic gouache, created by Jo Sonja and manufactured by Chroma Acrylic, which O'Neill applied with a small piece of coarse natural sponge. He also used the sponge to dabble, stipple, and spot the lower parts of the moss green surface with washes of Payne's gray and raw umber, followed by a wash of medium cadmium orange. The uppermost sunlit areas were further accented with Jo Sonja's Turner's yellow. Then the entire limb was highlighted with short brushstrokes to give it a more plantlike texture.

Balancing the lights and darks of the mossy limbs took some experimenting, but O'Neill believes the effect, plus the gradation from distant abstract shapes to sharp foreground details, gives the painting its depth and appeal. More distant limbs received less accenting with light colors and were washed with Payne's gray to push them back.

The tanagers, which grade from bright orange to gray, were rendered in burnt umber and cadmium orange acrylic, over shadows of burnt umber and Payne's gray. Their wings and tail are black acrylic, mixed with Naples yellow gouache, for highlights.

O'Neill painted the ferns and large bromeliads last, opaquely, on top of everything, rendering them in gesso mixed with sap green acrylic, plus a touch of cobalt blue. Washes of sap green and Payne's gray acrylic gave form to the ferns.

RUFOUS-BROWED HEMISPINGUS
1986, acrylic, gouache, watercolor, 40" × 30" (101.6 × 76.2 cm).

Avoiding Over-Rendering
Guy Coheleach

MAGPIE JAY
1966, gouache, 16" × 24" (40.6 × 60.9 cm).

"When I was just starting out I thought bird painting was painting feathers," says Guy Coheleach. "I didn't know the meaning of mood or feeling." *Magpie Jay* was the first bird the artist, then a commercial illustrator, painted for publication. It was scheduled as a color page in an early issue of *Audubon* magazine, but plans changed and the image was dropped. Coheleach thinks it's just as well. "The bird is terribly wrong," he says. "There are a lot of mistakes. It's really the way *not* to paint a picture." To the artist's eye the jay, perched in a mesquite tree, appears to be six feet tall, and its feathers are over-rendered to the point where they look more like sheet metal. "I was trying to show how well I could draw," says Coheleach.

Working from a study skin and some photographs, the artist produced literally thousands of pencil sketches, drawing each of its feathers then erasing it, over and over again. "Instead of making it better, a lot of times I made mistakes that weren't there to begin with," he recalls. Painting the bird proved no easier. When Coheleach began laying in the color washes, he started with gray instead of black, building up the entire piece before he realized it was too pale and he had to readjust all the values. Now, he starts with the darkest areas. "If there's jet black in your painting, put it in right away so everything else falls into place," he advises. "Then there'll be fewer corrections later on. It was an important lesson to learn. The magpie jay's plumage is ultramarine blue over a transparent red wash, which gives it a slightly purplish cast.

By the time Coheleach painted *Indian Rollers*, which was done in the field in Sri Lanka about ten years later, the artist had learned some lessons. His drawing skills were improved—witness the top bird's foreshortened wing—and his rendering of feather tracts had softened. He also had learned to lay the blacks in first to establish his values, and had become more adept with the watercolor properties of gouache. By laying successive transparent washes of phthalo green, ultramarine blue, and spectrum violet over a base of burnt sienna, he conveys the iridescence of the rollers' plumage. Showing one bird on the upstroke and the other on the downstroke captures the energy of flight.

Although Coheleach still occasionally produces highly detailed work, he also paints large-scale impressionistic pictures, such as *Waterside Mallards*, shown on page 51. And in the years since *Magpie Jay* failed to make the pages of *Audubon*, Coheleach's portraits, of both birds and big cats, have been featured in the magazine many times.

INDIAN ROLLERS
1974, gouache, 20" × 26" (50.8 × 66 cm).

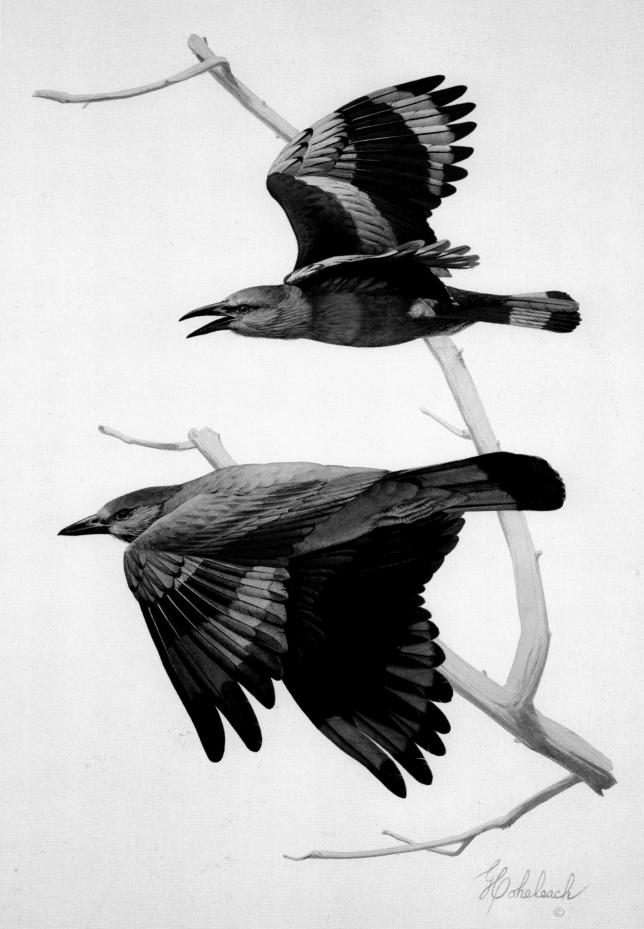

Indian Roller
(Coracias benghalensis indica)
Wilpattu, Ceylon

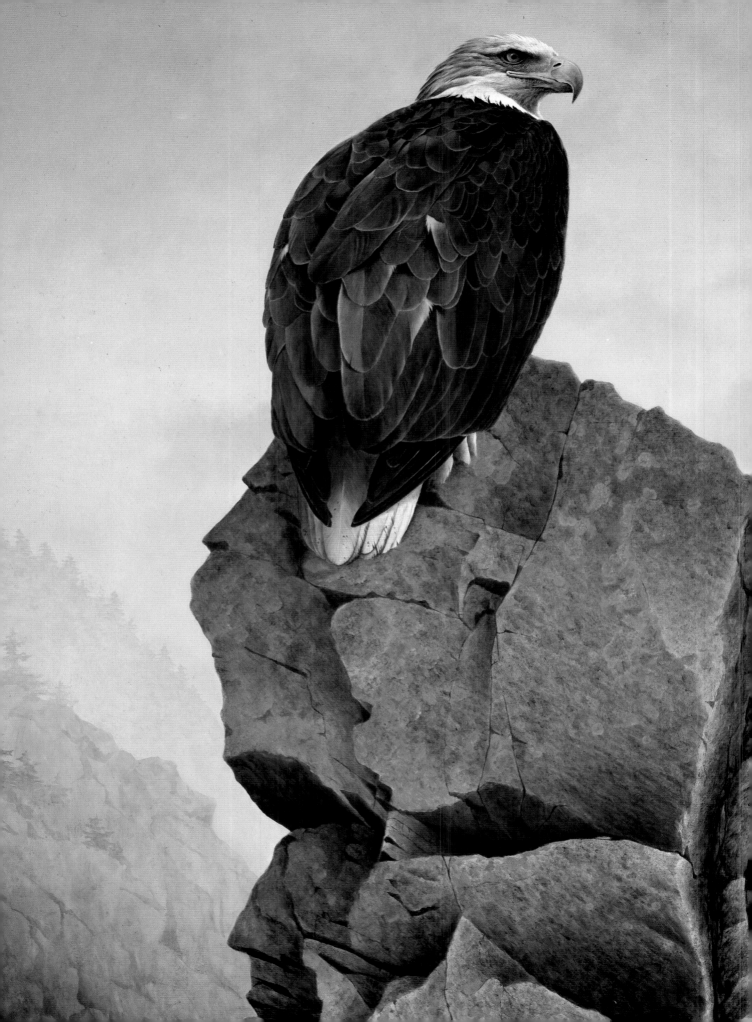

The Predators

Choosing the Right Format
Raymond Harris-Ching

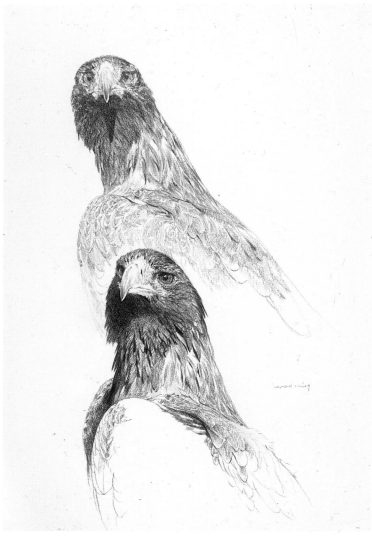

Harris-Ching has yet to develop any of dozens of pencil studies of the wedge-tailed eagle, made over the past twenty years. Closest are the watercolor head studies, such as the one shown here.

The huge size and rangy appearance of Australia's great wedge-tailed eagle, one of the world's largest birds of prey, gives it a forceful attraction not easily ignored, according to Raymond Harris-Ching. Central to this watercolor study is the business end of the predator—its massive beak, which the artist has emphasized by making it smooth and hard-edged, in contrast to the softness of the feathering.

The eagle's glaring eyes are the focal point of the picture and received careful attention. It is the eye contact that draws the observer into the painting. Advises Harris-Ching: "Don't allow yourself to get into a formula and paint every eye with a white highlight. Have a look. See if there's a bit of sky reflected in it, or if the bottom rim is wet. Paint what you see!" What the artist saw here was a highlight in the left eye, none in the right.

The eagle's plumage was painted primarily in burnt sienna, mixed with ultramarine blue and warmed slightly, where required, with a touch of raw sienna. The blue-black throat feathers were dusted with a thin wash of Naples yellow.

Because this watercolor is a study, it is painted on a relatively modest scale. Had Harris-Ching attempted a finished painting of the eagle, he would have worked much larger. "All paintings have their correct size. If this isn't realized, then the work will look uncomfortable," says the artist. Small birds, such as sparrows and chickadees, look best contained in a modest scale. Heroic birds, such as eagles and great albatrosses, feel more comfortable on a surface measuring several feet. "Indeed, if this isn't observed," says Harris-Ching, "the viewer may feel distinctly ill at ease. The painting may take on pretensions, or be over-retiring."

WEDGE-TAILED EAGLE
1978, watercolor, 14½" × 19½" (36.8 × 49.5 cm).

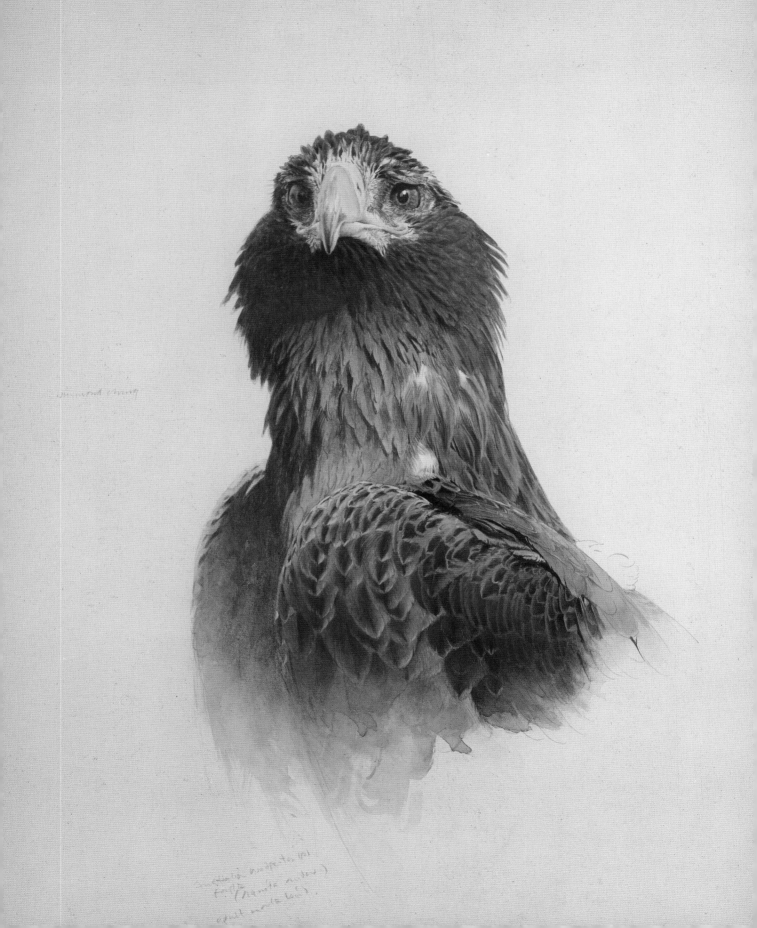

Capturing the Softness of Feathers
Lindsay B. Scott

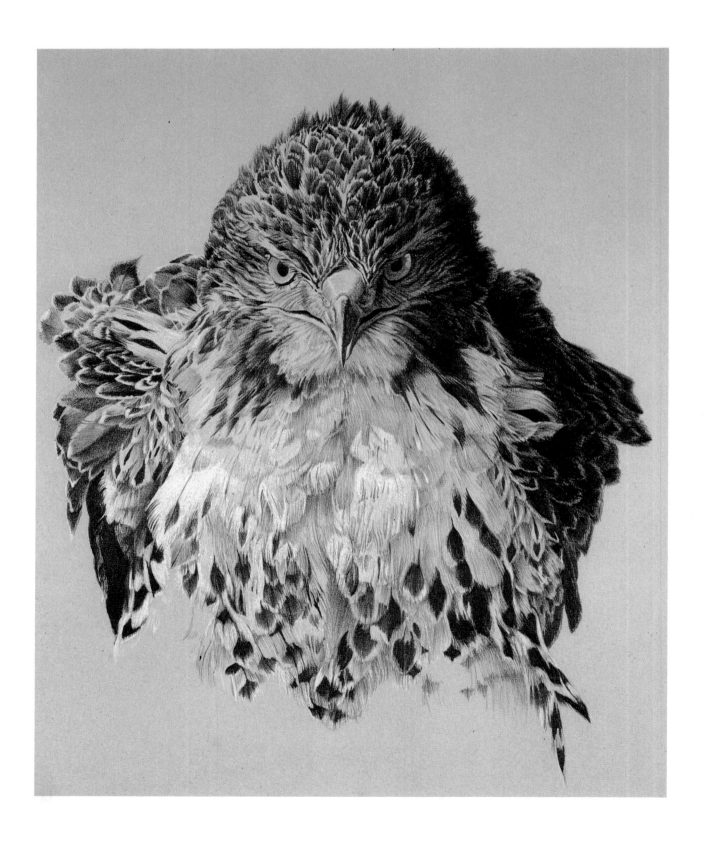

This young red-tailed hawk, staring out of the picture as though the viewer is the prey, was the pet of a local falconer. Ruffled feathers add to its threatening aura. The hawk was rendered in pencil on pastel paper, which adds warmth to the piece and allowed the artist, Lindsay Scott, to use white highlights.

Scott started with the eyes and beak, the hawk's most distinctive features. She found the full frontal angle difficult and had to fight an urge to flatten the beak and balance the bird's natural asymmetry. "In animals, as well as humans, the two sides of the face are never the same," she notes. Even the hawk's eyes are not identical. In an odd reversal, the left eye is in the light but has no highlight, whereas the right eye has a highlight, although it's in shadow. Scott draws what she sees. "People tend to put a highlight in every eye but often it's really not there," she says. "Just putting one in is not realistic and it often makes the painting look somewhat sentimental."

Scott worked the dark areas first, carefully keeping the light areas blank. Unwanted pencil marks would have left indentations on the board, and attempts to erase them would have permanently changed the surface texture.

Capturing the softness of feathers is largely intuitive but having a delicate touch helped. "I feel the softness, then try to make my touch on the paper the same kind of softness," says Scott. "With pencil, touch is very important. I try to be as soft as the feathers look." She uses an HB pencil, often practicing on a spare piece of paper before she tackles the final piece. "Getting a light, even touch with lead is one of the most difficult aspects of pencil drawings," says Scott. "It's almost like an opera singer doing scales to get in good voice. I cannot do pale areas first thing in the morning, for instance."

Scott achieves texture by moving just her fingers and wrists to create fine lines, never more than a quarter-of-an-inch long. She does not crosshatch, preferring to have all her strokes go in one direction, overlapping them and varying the thickness to build form. If she is working on a rounded shape, such as a feather, her lines will follow the feather's contour. Framed in vignette, the red-tailed hawk has an almost heraldic presence. White crayon highlights were added last.

"In wildlife art accuracy is essential," says Scott, "and that can only be gained by really knowing your subject matter." She finds sketching one of the best ways to understand structure and function.

YOUNG RED-TAILED HAWK
1985, pencil and crayon, 16" × 12" (40.6 × 30.4 cm).

Conveying Speed
Guy Coheleach

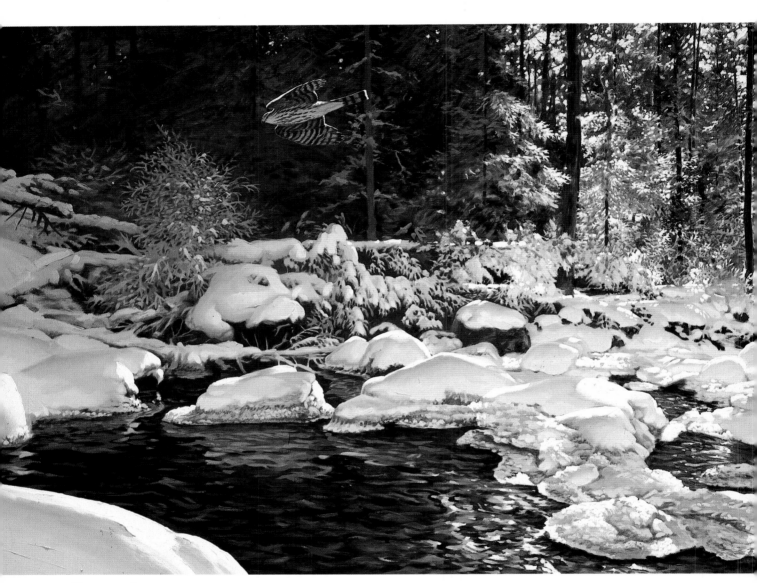

WINTER SHARPIE
1984, oil, 6' × 3' (182.8 × 91.4 cm).

It's a winter morning at Yellowstone National Park—cold and clear. Sunlight pours through the tall pines, bouncing off the snow and adding dazzle to the scene. Suddenly, a bird flashes past and is gone. The beauty of the setting may well be lost on the hawk—all business on its first run of the day.

Birds of prey are a favorite subject for artist Guy Coheleach, who raised them as a teenager. He started this painting as a large impressionistic landscape, then added the hawk as a point of focus. To convey the hawk's speed, he tilted it downward, wings folded close to the body. If the wings had been farther outstretched, the bird would appear to be floating, rather than darting past in swift flight. As it is, the viewer senses that, with little visible air support, the hawk must be going very fast—or it would fall to the ground.

Unlike Coheleach's more tightly rendered work, which begin with detailed pencil sketches, he drew this scene directly on the canvas, loosely blocking in the darks and lights with a wide brush. To save time, he underpainted the large picture with an overall wash of burnt sienna alkyd (a fast-drying acrylic paint that covers like oil but dries in hours instead of days). "I have been trying to put more color in my work these days," says the artist. "If I'm doing a cool painting, I'll start off with a very hot orange underbase, which forces me to contrast it by attacking the blues more boldly."

Coheleach worked up the trees first, using flecks of pure cadmium yellow, burnt sienna, and tints of cobalt blue. The branches and needles were done with a few choppy strokes and a splayed brush. From years of observation, Coheleach knows sunlight seen through trees is so much brighter than the surrounding forest that it seems to expand, making spots of light appear larger than they actually are. To convey the optical distortion, the artist allows more space for light effects among the trees than he knows should be there. "I'm not trying to fool the eye, I'm trying to give an impression, a feeling," says Coheleach. "My trees are made with paint; they are not made with leaves."

The darker parts of the hawk were painted with a mixture of what was left on the palette after Coheleach had painted the dark area of the trees. The bird's breast is yellow ochre, with highlights of cadmium yellow mixed with white.

Although they appear brilliant white, the snowy boulders are warmed with a touch of yellow ochre. After putting in the shadows—white mixed with mauve—Coheleach came back with raw tube white for the highlights. Flecks of cobalt blue enliven the water.

Although pleased with the painting, the artist notes one problem: "It looks like a dark picture on the left and a light one on the right." To compensate for the split, Coheleach added bright snow in the lower left corner, which brings the eye across the canvas and unifies the work.

Integrating Color to Create a Mood
Richard Casey

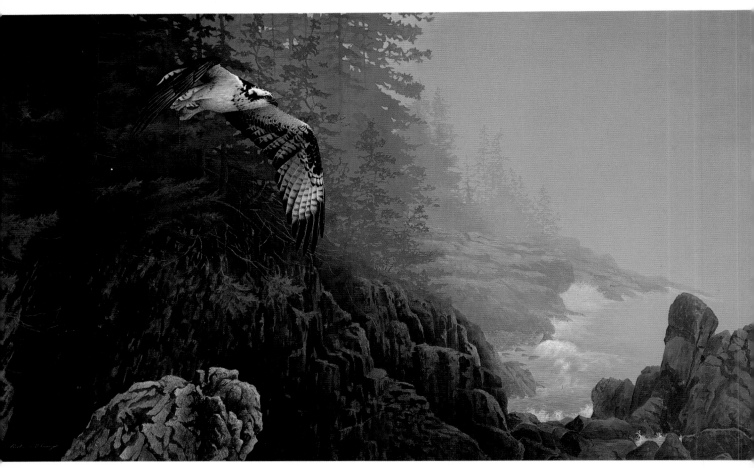

IN THE FOG—OSPREY
1985, oil, 60" × 26½" (152.4 × 67.3 cm).

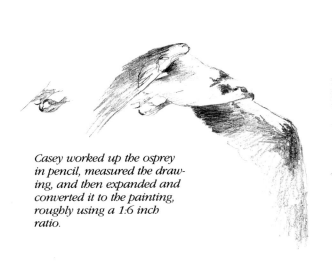

Casey worked up the osprey in pencil, measured the drawing, and then expanded and converted it to the painting, roughly using a 1:6 inch ratio.

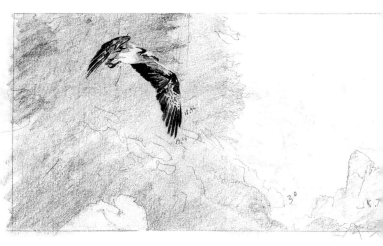

He was walking along a deer path that edges the high cliffs, near the back shore of his island home in Maine, when he stepped out on a jagged rock to look up the coastline. "I saw it all then," says Richard Casey. "The fog had swept in obscuring the lighthouse. Spruce and stone were muffled in the haze and I heard the ringing of the harbor bells, while above came the keen call of an osprey somewhere in the distance." The deer path provides the only access to ancient ground where Indians once buried their dead. "When you look out from here, especially in a fog, something comes over you," Casey adds. "Here I feel as if I stand on the cutting edge of the spirit."

The artist set up his easel on the rocks and began to compose the scene. To emphasize the sense of mystery, he pushed the design out to the right, encompassing as much of the flat grayness of the fog as he could and still balance it with the complexity of the shoreline. The painting is divided in half between coast and fog, with the osprey meant as a changeling, capable of passing across the barrier.

Casey's main objective was to incorporate all the elements of the painting into a unanimous whole, using fog as the uniting element. "Getting its presence into every inch of the painting was difficult," he says. "It seeps into feather and spruce needle, mingling with the air and giving it tangibility." The artist roughed out the scene in pencil, then blocked it in with a neutral tone. He wanted the negative expanse to dominate the painting, and so crammed cliff, spruce, and bird into the left corner so the eye would take in all the detail first, and then drift out into the large, seemingly unending wall of gray.

Casey painted the fog first, with an even mixture of Antwerp blue, raw umber, charcoal gray, and white. He then worked all over the panel at once, blocking elements in quickly to check his progress and see how the shoreline was receding into the mist. The trees are painted with fog color tinged with Naples yellow and Vandyke brown, with a touch of olive green. Those up close have ultramarine blue and raw sienna added. Oxide brown imbues the foreground cliffs with rustiness.

To find the right placement for the osprey, Casey moved simple cutouts of the bird's shape over the panel. "I settled on this pose because it captured a sense of motionlessness between wingbeats," he says. "And it helped to convey the feeling of hushed stillness so strongly associated with fog." For the correct anatomy and feather pattern, the artist relied on photographs and six years experience with a taxidermist. But ultimately, the shape of the wing is what the artist wanted it to look like, not what any picture dictated.

The white of the osprey is Weber's Permalba, which Casey prefers for its buttery texture and warm cast. Its body shadow is primarily fog color. In the end, a touch of violet was added to both bird and far trees, to create an overall harmony.

Casey worked on the painting on and off for a month, in sun as well as haze. "I didn't restrict myself to a certain time," he says. "As the light changed, I picked up what I liked and added a bit more." The picture is the culmination of an entire day.

Achieving Color Harmony Through Glazing

Richard Casey

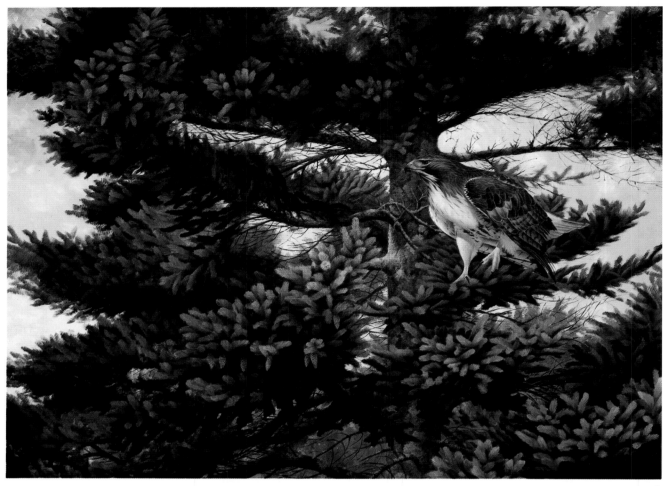

ONE WING ABOVE DREAM OR HUNGER
1986, oil, 48" × 36" (121.9 × 91.4 cm).

The idea for this painting began with the tree, which is just outside Richard Casey's bedroom window. "I had looked at it a hundred times before," says Casey, "but one day I saw a painting in it and began working on it that afternoon." He used the frame of the window to block off the area he wanted, then started right in on the large panel without any initial drawings.

Working from top to bottom and dark to light, Casey established the base colors and forms with opaque paint, to give them body. He built up the final color with successive layers of transparent glazes. Opaque colors (pigments cut with white) tend to bring objects forward. Glazes, which are thin layers of pure pigment, set them back into the painting again. To obtain rich densities, Casey often floats as many as a dozen glazes over a surface. "By glazing," he says, "I can fuse elements of a painting together in a color harmony, and the shiny surface of the painting itself is interesting." Here, some glazes went over one area, adding subtle variations in density. Others reached across the entire painting.

The artist's first mark was the line that goes right down the center of the trunk, where he used a base color composed of burnt umber, raw umber, and raw sienna. Prussian blue gave the darks a dense, velvety look. Working up and down the value scale with neutral greens, mixed from blues and yellows, Casey added yellows and

This watercolor of a red-tailed hawk (shown here actual size) became the model for the bird at left. Casey worked up the drawing from a thumbnail sketch, over a year's time, bringing the wings up, then down, and putting the tail in different positions to the point where he liked it. He then traced it off and reversed it for the final image.

whites to lighten the needles, and browns to darken them. Throughout the painting, textures are achieved through color. The bluish-white cast to the spruce needles at the tips of the nearest branches conveys their brittle, spikey quality.

Once the basic shape and position of the tree were structured and completely dried, Casey painted the sky— primarily Antwerp blue—right over it, to avoid dabbing in between the branches. He then worked on the tree again, adding middle tones as he progressed downward. Blobs of Naples yellow, mixed with white and a touch of blue, built up in some areas to a quarter of an inch thick, convey the nubbly, lichen-covered bark.

The bird was blocked in with yellow ochre cut with white for the breast, and raw umber and gray on the body. Casey painted its head carefully to capture the particular intensity essential for birds of prey, applying half a dozen thin glazes of brown ochre and Vandyke brown to give the eye a glassy look. The shadow areas on the hawk's lower breast and legs were built up with successive glazes of raw sienna and a touch of burnt sienna, and then further glazed with browns and grays. The wing is a duller gray-brown, glazed with Vandyke brown. The bird's feet are a mixture of white and Naples yellow, with a touch of cadmium yellow light—"dirtied" with a glaze of charcoal gray.

Painting Snow

Robert Bateman

"I saw that a blizzard was starting one winter day, so I put on my parka and boots and headed out to experience it," says artist Robert Bateman. "It was one of those sudden squall storms that accompanies a cold front and hits hard and fast. Very exciting! Big splats of snowflakes soon plastered my clothes and skin. I could hardly breathe, and when I did, I was breathing snow."

Camera in hand, Bateman hiked to his favorite pine tree, long ago sculpted by the prevailing wind, and full of dynamic rhythm. He used its strong diagonal slant, exaggerated to suit his needs, as the basis for this composition. It is a purposefully uncomfortable format, in that everything is thrust down to the lower right corner, leaving an awkward triangle at the upper left.

After working up much of the detail, Bateman ran a housepaint roller over the entire picture, with a thin gray mixture of ultramarine blue, raw umber, and opaque white. The chalky paint screens the details and at the same time establishes the values and tones, providing an interesting surface that is full of small bumps and paint particles. He then repainted the tree with more high-key tones.

Bateman based his drawing of the red-tailed hawk on a specimen from his freezer, thawed so that its wings could be spread. With the aid of a helper, who tipped the bird at different angles, he established its pose and painted it on bristol board, which he then cut out and moved around the picture with masking tape. The logical place for the hawk would have been the empty space in the upper left corner but Bateman found that solution "too pat." He finally decided on the lower left, as if the hawk had lost control and was about to be blown out of the picture. "He made a mistake taking flight in such a storm," notes the artist. "Perhaps he was caught by its suddenness on an exposed perch. He is in a lot of trouble but may be able to turn and beat his way upwind to the shelter of the lee side of the tree." Finally satisfied with its placement, Bateman traced the bird's outline around the cutout and painted it in.

To make snow, Bateman mixed a margarine tub of white paint to the consistency of heavy cream and spattered it across the surface by smacking one large hog's hair brush against the handle of another, aligning himself so that the spatters would fall horizontally left to right, in the direction of the storm. "I always have trouble getting my white opaque to be white and opaque enough," says the artist. "I don't know why. There just doesn't seem to be a paint invented that can paint a white over a dark and be as white as the paper is."

He then killed the scene with another coat of very thin gray, this time applied with a sponge. "I wanted the painting to be very flat and faded, almost like a Japanese screen," he explains. Finally, he went over the entire surface with carefully painted snowflakes, trying to make them look random. Says Bateman, "You can't have all the flakes on one plane. They are everywhere. There have to be flakes between the pines in the foreground and the pines in the background and between the bird and the pine."

SUDDEN BLIZZARD—RED-TAILED HAWK
1985, acrylic, 60" × 36" (151.4 × 91.4 cm).

Biographies of
the Artists

Robert K. Abbett

Robert Bateman

Keith Brockie

Richard Casey

Guy Coheleach

Raymond Harris-Ching

David Maass

Lawrence B. McQueen

John P. O'Neill

Manfred Schatz

Lindsay B. Scott

Keith Shackleton

Robert K. Abbett

Summer Drummer, *1987, oil, 30" × 20" (76.2 × 50.8 cm).*

A sportsman himself, Robert Abbett is one of America's most accomplished painters of sporting and outdoor art. He is equally well known for his intimate New England landscapes and spirited western scenes, some of which hang in the National Cowboy Hall of Fame, in Oklahoma.

In addition to his other projects, Abbett travels around the country to work on private commissions of sporting dogs. His paintings also have been selected for numerous conservation stamps. "Like most artists I talk with," he says, "the landscape is the primary urge—and wildlife the catalyst that turns the landscape into a living thing or experience."

Born in Indiana in 1926, Abbett is a graduate of Purdue University and the University of Missouri. After formal training at the Chicago Academy of Fine Art, he pursued a career in advertising, until a commission to paint an English setter named Luke, his first animal portrait, led him from illustration to becoming a full-time artist.

Abbett has been featured in many magazines, including *Sporting Classics, Sports Afield, Yankee,* and *Southwest Art.* He currently is finishing a second volume of his work, *A Season for Paintings.* His first book, *The Outdoor Paintings of Robert K. Abbett,* was published in 1976.

The artist divides his time between his home in the Connecticut countryside and a studio in Arizona, where his father and grandparents once lived. Abbett is represented by Wild Wings, Lake City, Minnesota; the King Gallery, New York City; and the May Gallery, in Scottsdale, Arizona.

Robert Bateman

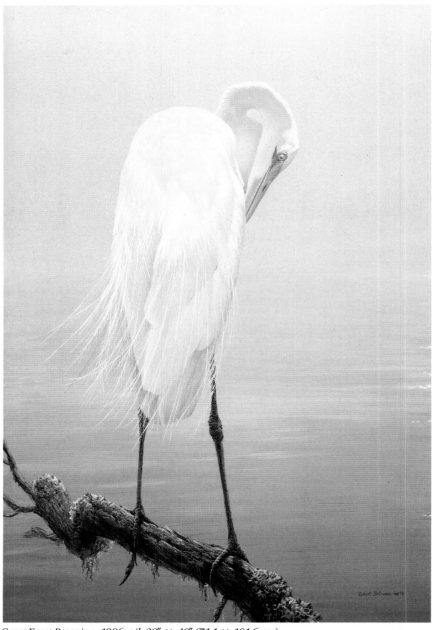

Great Egret Preening, *1986, oil, 28" × 40" (71.1 × 101.6 cm).*
© 1986 Robert Bateman. Courtesy of the artist and
Mill Pond Press, Inc., Venice, FL 34292-3502.

Born in Toronto, Canada, in 1930, Robert Bateman was painting birds and animals by the time he was twelve. He studied geography and art at the University of Toronto and taught both subjects for several years before turning to wildlife art full-time.

During his twenties and thirties, Bateman worked in different styles, drawing on such diverse influences as Cézanne, Picasso, Franz Kline, and Andrew Wyeth. All helped to evolve his present style—an uncontrived realism. "Art is like music," says the artist. "You orchestrate the painting, giving it a theme which is echoed over and over."

Today, Bateman's work hangs in museums worldwide, as well as in private and royal collections, including those of England's Prince Charles and the late Princess Grace of Monaco. His paintings are so sought after by collectors that buyers must be selected by means of a draw.

Bateman is the subject of five films, and two books have been produced about his work: *The Art of Robert Bateman* (1981) and *The World of Robert Bateman* (1985). His prints are provided by Mill Pond Press, Venice, Florida.

Keith Brockie

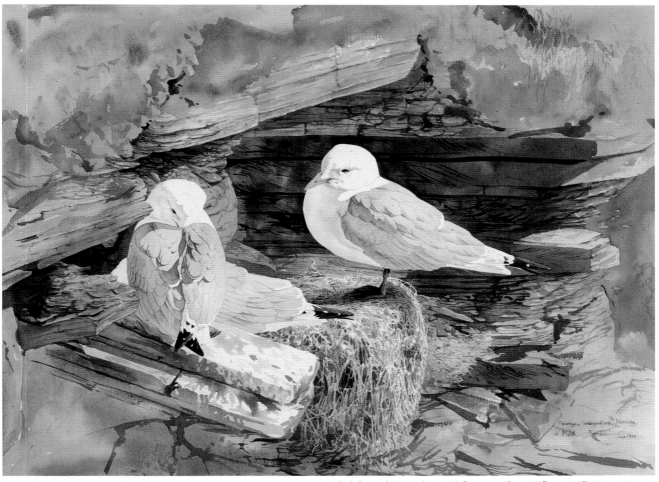

Black-legged Kittiwakes, *1986, watercolor, 18½" × 13½" (47 × 35 cm).*

At age thirty-three, Scotsman Keith Brockie is one of the finest artist-naturalists in the world. He usually winters at his home in the Dundee countryside, but come early spring the artist is out exploring the cliff islands and tundra of northern Europe, observing wildlife with "an awareness and sense of wonder."

Working quietly, Brockie often sits within feet of his subjects, or draws them through a telescope mounted on a tripod. He travels light, with a portable drawing board and folder with assorted colored papers. Drawing equipment is kept in a multipocketed fisherman's vest. The artist has worked in similar fashion in North Yemen, Africa, and Greenland.

In 1978 Brockie received a diploma in illustration and printmaking from the Duncan of Jordanstone College of Art in Dundee, Scotland. He then worked briefly as an illustrator at the Dundee Museum, before becoming a freelance artist the following year.

The artist's first book, *Keith Brockie's Wildlife Sketchbook*, was published in 1981. Three years later came *One Man's Island*, representing a year of sketching and painting the seabird colonies on the Isle of May, in the North Sea. Brockie's third book, *The Silvery Tay*, featuring wildlife on the River Tay in central Scotland, will be published in the fall of 1988.

Richard Casey

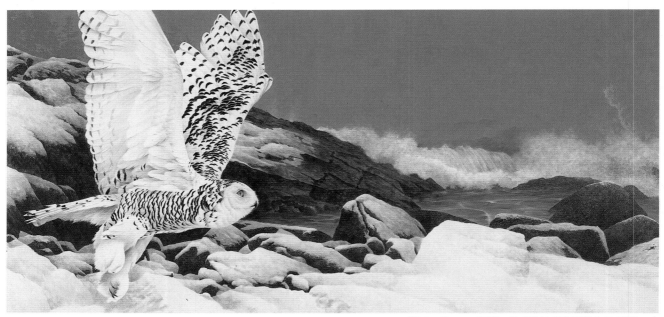

Winter Shores, *1988, oil, 56" × 27" (142.2 × 68.5 cm).*

"Words to me seem a violation of art, which ultimately must stand alone in silence. It is not what an artist says about his work but what it says to others." Richard Casey and his wife, Diana, live on an island off the coast of Maine. Surrounded by wilderness and ocean, the artist is constantly in touch with the land and the birds and animals that figure so strongly in his work.

Casey was born in 1953 and grew up in Milford, Connecticut. The nearby marshes, filled with wildlife, were the stage for his childhood adventures. He received a degree in science from the University of Connecticut, and for six years was assisted in his artwork by the chief taxidermist at Yale University's Peabody Museum, who taught Casey about animals "inside out."

Nonrealistic forms of expression were the emphasis of his art classes, although he rejected the formal approach to art. While honing his drafts-manship and acquiring the essential skills to be an artist, Casey preferred to spend his hours outdoors, among the wild things he has always been comfort-able with. "My paintings emerge from an idea, and my artistic vocabulary happens to be the elements of nature," he says. "Here on this island there is an abundance of birds and animals. In a real sense, I can participate in the seasons, the passage of tides, and the movement of the sun, moon, and stars, which change subtly but perceptibly day after day."

Casey's work is influenced by Winslow Homer, the late works of Turner, and American realist Andrew Wyeth. His paintings are found in corporate and private collections around the country. He is represented by King Gallery, New York; Pacific Wildlife Gallery, in Lafayette, California; and Mill Pond Press, Venice, Florida.

Guy Coheleach

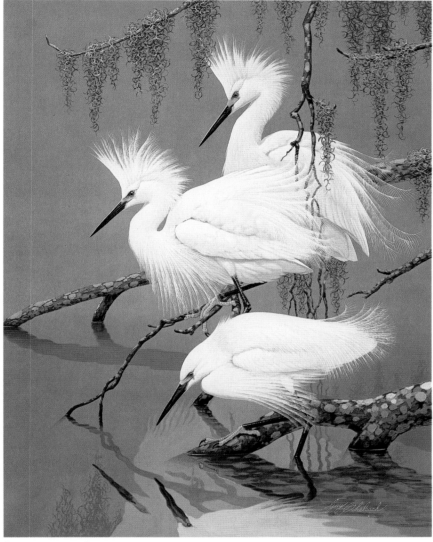

Snowy Egrets, *1968, gouache and casein, 26" × 36" (66 × 91.4 cm).*

Guy Coheleach (pronounced KO-lee-ak) has climbed mountains, tracked lions and buffalo, and caught venomous snakes all over the world. Elected a fellow to the prestigious Explorer's Club, he was also the youngest member ever admitted to the Adventurers Club of New York.

A graduate of Cooper Union Art School, Coheleach was working in the advertising field when he was asked to paint a bird calendar. It was the start of his career as a wildlife artist. Since then his paintings have been exhibited worldwide, including the Corcoran Gallery and the National Collection of Fine Arts in Washington, D.C.; the Royal Ontario Museum in Toronto; and in Beijing, China. In 1983 Coheleach was elected Master Artist of the "Birds in Art" show at the Leigh Yawkey Woodson Museum of Art in Wausau, Wisconsin.

An ardent conservationist, Coheleach has contributed original paintings and prints to many conservation organizations, raising millions of dollars for such groups as the National Wildlife Federation, National Audubon Society, Game Conservation International, and The Fund for Animals, Inc.

A book of his work, *The Big Cats*, was published in 1984. Coheleach is represented by Petersen Prints, in Los Angeles, and Pandion Art, in Bernardville, New Jersey, where the artist resides.

Raymond Harris-Ching

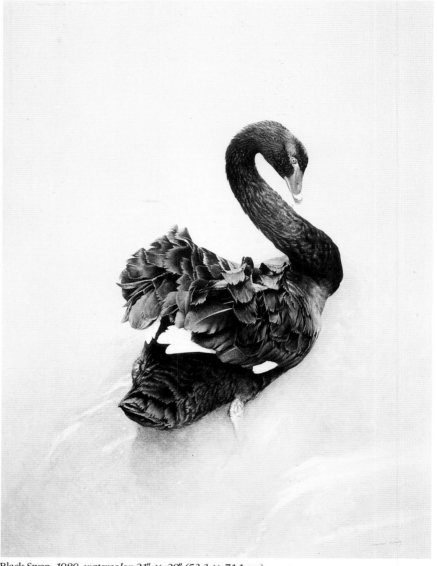

Black Swan, *1980, watercolor, 21" × 28" (53.3 × 71.1 cm).*

Renowned for his fine drafts-manship, Raymond Harris-Ching is represented in museums and private collections around the world. The artist is equally well known for his portraits, landscapes, still lifes, and the nude.

Harris-Ching was born in 1939 in New Zealand, where his great-grand-parents settled after leaving England in the 1830s for a life in the New World. (The artist's curiously un-English-sounding family name is, in fact, of Cornish origin.) Harris-Ching maintains permanent studios in both New Zealand and England, to which he returns to complete the finished paintings from drawings and studies collected in his extensive travels.

The artist is self-taught. He quit school at age twelve and left home shortly thereafter, living as a street urchin. Several years later, he met two artists who invited him to attend an evening art class, where he discovered his innate talent.

In 1968, Harris-Ching completed 250 drawings for *The Book of British Birds*, published by the Reader's Digest. Since then, four large coffee-table books have been published on his work: *The Bird Paintings, Studies and Sketches of a Bird Painter*, and *The Art of Raymond Ching*, and *New Zealand Birds*. Another volume, *Wild Portraits*, is in progress. Harris-Ching is represented by the Tryon Gallery, London, England.

David Maass

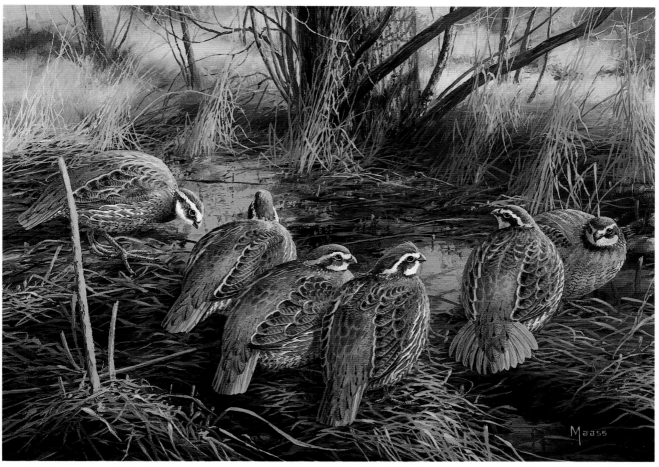

1986 International Quail Foundation Research Stamp, *oil, 19″ × 14″ (48.2 × 35.5 cm).*

Raised by parents who enjoyed hunting and fishing, David Maass began drawing at the age of four. The combination of art and outdoors experience led him to a career in wildlife art—specializing in waterfowl and upland birds. "Just give me a scene with lots of wind, diving ducks and an expanse of sky," says the artist.

Maass received his training from the Minneapolis Art Instruction's correspondence course. He was discovered after showing his work at Abercrombie & Fitch and Crossroads of Sport, in New York City. Since then, his paintings have been shown in museums and galleries throughout the country, including the Smithsonian Institution's National Collection of Fine Art, in Washington, D.C., and the Leigh Yawkey Woodson Museum of Art, in Wausau, Wisconsin.

Maass has designed numerous state and federal duck stamps and conservation stamp prints, and was named Artist of the Year by Ducks Unlimited. His work is featured in the book *A Gallery of Waterfowl and Upland Birds*, published in 1978. The artist lives with his family in a home on the shore of Lake Minnetonka, near Minneapolis. He is represented by Wild Wings, Lake City, Minnesota.

Lawrence B. McQueen

"Art has been a way for me to make a connection with the natural world," says Lawrence McQueen. "Birds, especially, have provided the link. But it is the natural environment in its most pristine state that has always held the greatest fascination for me because it is charged with forces unknown—yet familiar—as these forces are within us. It is this unnamed spirit of existence that I mean to instill in my painting."

McQueen has been watching birds since his childhood in Pennsylvania. He received a degree in biology from Idaho State University in 1961.

He worked for the Idaho State Game Commission, investigating the predatory relationship of golden eagles to antelope.

McQueen studied art at the University of Oregon. For twelve years part-time, he was staff illustrator at the Oregon State Museum of Anthropology and worked as a graphic artist. Since then, he has taught many art and ornithology classes, including a summer seminar on nature painting at the Asa Wright Nature Center in Trinidad. Chief among his influences have been master wildlife artists Louis Agassiz Fuertes and Bruno Liljefors, as well as his contemporary, Don R. Eckelberry.

The artist's work has been published in regional bird books; field guides; and in various journals and magazines, including *National Wildlife*, *Animal Kingdom*, and *Audubon*. McQueen currently is working on a field guide to the birds of Peru. He resides in Eugene, Oregon.

Townsend's Warbler's, *1985, watercolor, 11" × 14" (27.9 × 35.5 cm).*

Paul Neevel

John P. O'Neill

Golden-backed Mountain Tanager, *1985, acrylic, gouache, watercolor, 30" × 20" (76.2 × 50.8 cm).*

John O'Neill began his career as a research ornithologist, but his interest in birds soon led to painting them as well. He first visited Peru in 1961 and has returned almost every year since, often for several months at a time. He has discovered and described more new bird species than any other living person—and often has been first to illustrate them.

The rest of the year, O'Neill serves as coordinator of field studies and artist-in-residence at the Louisiana State University Museum of Natural Science, in Baton Rouge. He received his Ph.D. in zoology from the University of Oklahoma and Louisiana State University, and studied art under renowned naturalist-artist George Miksch Sutton. Fellow artists Don R. Eckleberry, Lars Jonsson, and Lawrence B. McQueen also have influenced his work.

O'Neill's paintings have been reproduced in *Audubon* magazine; and in books and field guides, including the Audubon Society *Master Guide to Birding* and *The Field Guide to the Birds of North America*, published by the National Geographic Society. He currently is coordinating a major book on the birds of Peru. The artist wants to use his art to help conservation in South America. He lives in Baton Rouge, Louisiana.

Manfred Schatz

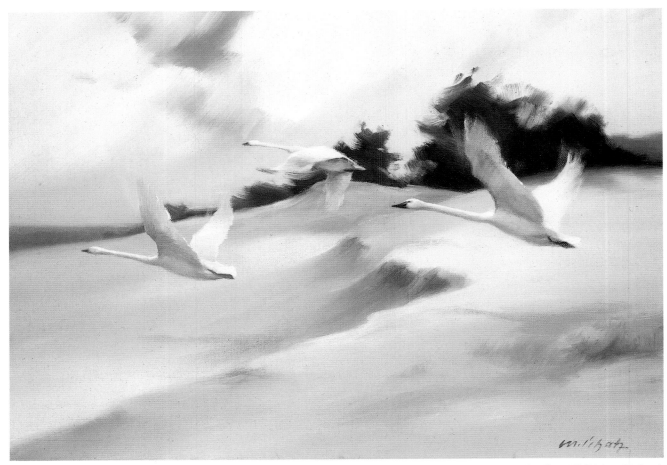

Windriders, 1985, oil, 21" × 15" (53.3 × 38.1 cm).

With his uncanny ability to capture wildlife in blurred motion, Manfred Schatz has earned international acclaim. He is the recipient of numerous awards, and his works can be found in museums and private collections all over the world.

Schatz was born in 1925, in what is now a part of Poland. At seventeen, he was the youngest student ever accepted by the Academy of Fine Arts in Berlin, where he studied to be a portrait painter. During World War II, Schatz was drafted into the German army and sent to the Russian front, where he was captured and spent four years as a prisoner of war. Painting hunting scenes for Russian officers may well have saved his life.

When he finally was released from prison, suffering from starvation and tuberculosis, Schatz weighed just ninety-eight pounds. To recover his health, the artist moved to a hunting preserve in northern Germany, where he began to paint wildlife in earnest. Today, he lives near Dusseldorf, West Germany, and often travels to Scandinavia, 1,200 miles north, to observe and paint the animal life there.

Schatz' impressionistic style has been influenced by the works of Swedish masters Bruno Liljefors, Anders Zorn, and, more recently, American impressionist, James McNeill Whistler. He is represented by the Russell A. Fink Gallery, Lorton, Virginia.

Lindsay B. Scott

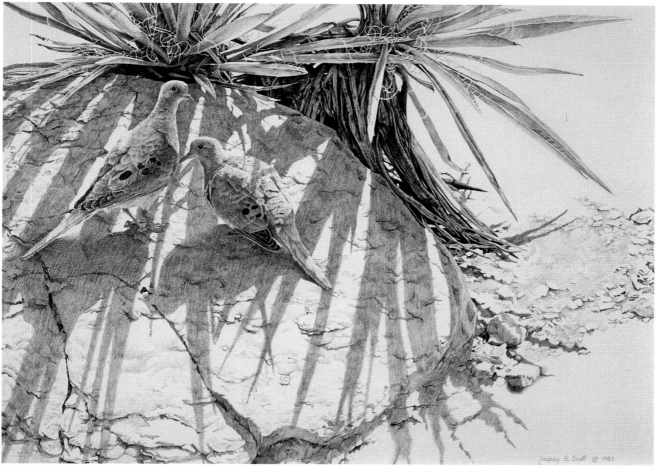

Morning Shade, *1983, pencil, 14½" × 11" (36.8 × 27.9 cm).*

Born and raised in Zimbabwe, Africa, Lindsay Scott learned to appreciate wildlife early.

She attended the University of Capetown, and several years later graduated from the University of Minnesota with a fine arts degree and a minor in biology. Later on in her career, Scott studied the bone collection at South African Museum, Capetown, which gave her first-hand knowledge of animal anatomy.

In 1984–85, Scott traveled to Australia on a research grant awarded by the National Geographic Society to study stilts and avocets, wading birds. Seeing the work of Robert Bateman inspired her to paint her first wildlife piece. "Painting has allowed me to combine my two major interests in life—biology and art," says Scott. "Being in nature, and trying to understand how and why it functions, has been the most rewarding thing I have done."

Unlike most other wildlife artists, Scott prefers the control of pencil. At one point she studied the work of black-and-white photographer Ansel Adams for his mastery of composition and creating moods. In 1985, *Morning Shade*, shown above, won Best of Show in the wildlife category of the International Wildlife, Western and Americana Art Show in Chicago. Second place went to Scott as well, for a black-and-white drawing of elephants.

Having witnessed the decline in African wildlife over the past few decades, Scott has become an ardent conservationist. She is represented by G. W. S. Galleries in Carmel, California, and Fowl Play, in Ventura, where she lives.

Keith Shackleton

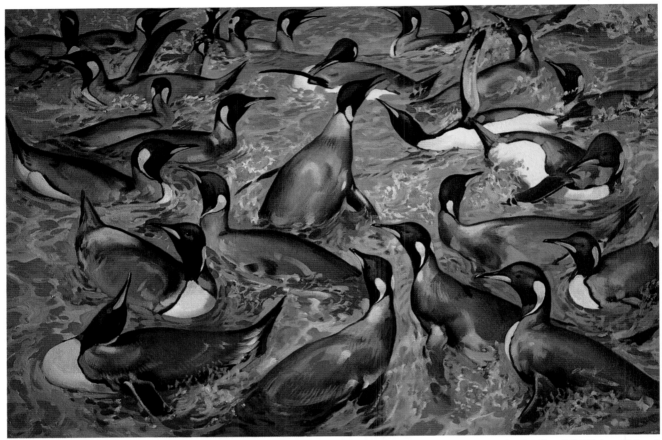

Royal Bathing Party, King Penguins, 1986, oil, 36" × 24" (91.4 × 60.9 cm).

Distantly related to Sir Ernest Henry Shackleton, the famous Antarctic explorer, Keith Shackleton shares the same passions. His travels, often aboard the adventure ship, *Linblad Explorer*, have taken him all over the world. But his favorite landscapes remain the high latitudes. "I love the tropics, and the tropical style of existence," says the artist, "but when it comes to painting and the visual motivation a subject exerts, the ice surpasses everything: the ice and, of course, the sea."

Shackleton's interests are wide-ranging: artist, naturalist, explorer, pilot, yachtsman, broadcaster, and author. He spent five years in the Royal Air Force, in Europe and the Far East; and several times represented Great Britain in International Dinghy meets, four times crewing the winning boat in the Prince of Wales Cup.

He is a widely regarded marine and wildlife artist, and is past-president of London's Royal Society of Marine Artists and the Society of Wildlife Artists, as well as current chairman of the Artists League of Great Britain. He never attended art school.

Shackleton is the author of several books, the most recent a collection of his polar marine paintings, entitled *Wildlife and Wilderness: An Artist's World*, published in 1986. He lives in London, and is represented in the United States by Mill Pond Press, Venice, Florida.

Credits

Frontispiece. Courtesy of the artist.

Title page. © 1978 Robert Bateman. Courtesy of the artist and Mill Pond Press, Inc., Venice, FL 34292-3505.

p. 8. Courtesy of the artist.

pp. 10–11. © 1985 Robert Bateman. Courtesy of the artist and Mill Pond Press Inc., Venice, FL 34292-3505.

p. 13. © 1980 Robert Bateman. Courtesy of the artist and Mill Pond Press, Inc., Venice, FL 34292-3505.

pp. 14, 15. Courtesy of the artist.

pp. 16, 17. Courtesy of the artist.

pp. 18, 19. Courtesy of the artist.

pp. 20, 21. Courtesy of the artist.

pp. 22, 23. Courtesy of the artist.

pp. 24, 25. Courtesy of the artist.

pp. 26–27. © 1984 Robert Bateman. Courtesy of the artist and Mill Pond Press Inc., Venice, FL 34292-3505.

p. 29. © 1977 Robert Bateman. Courtesy of the artist and Mill Pond Press, Inc., Venice, FL 34292-3505.

pp. 30–31. © 1982 Robert Bateman. Courtesy of the artist and Mill Pond Press, Inc., Venice, FL 34292-3505.

pp. 32, 33. Courtesy of the artist.

pp. 34, 35. Courtesy of the artist.

p. 37. Courtesy of the artist.

pp. 38–39. Courtesy of the Russell A. Fink Gallery, Lorton, VA.

p. 40. Courtesy of the artist.

p. 41. © 1983. Courtesy of the artist David A. Maass and Wild Wings, Inc., Lake City, MN.

pp. 42–43. © 1984. Courtesy of the artist David A. Maass and Wild Wings, Inc., Lake City, MN.

pp. 44, 45. Courtesy of the artist.

pp. 46, 47. Courtesy of the artist.

pp. 48–49. Courtesy of the artist.

pp. 50–51. Courtesy of Pandion Art, Bernardsville, N.J.

pp. 52, 53. Courtesy of the artist.

pp. 54, 55. Courtesy of the artist.

pp. 56–57. © 1981 Robert Bateman. Courtesy of the artist and Mill Pond Press, Inc., Venice, FL 34292-3505.

pp. 58–59. © 1981. Courtesy of the artist Robert K. Abbett and Wild Wings Inc., Lake City, MN.

p. 60. © 1985. Courtesy of the artist David A. Maass and Wild Wings, Inc., Lake City, MN.

p. 61 (top, middle). Courtesy of the artist.

p. 61 (bottom). Courtesy of the Maine Department of Inland Fisheries and Wildlife.

pp. 62–63. Courtesy of the Russell A. Fink Gallery, Lorton, VA.

pp. 64–65. Courtesy of the Russell A. Fink Gallery, Lorton, VA.

pp. 66–67. © 1980 Robert Bateman. Courtesy of the artist and Mill Pond Press, Inc., Venice, FL 34292-3505.

pp. 68, 69. Courtesy of the artist.

pp. 70–71. © 1982 Robert Bateman. Courtesy of the artist and Mill Pond Press, Inc., Venice, FL 34292-3505.

p. 72. Courtesy of the artist.

p. 73. Courtesy of Pandion Art, Bernardsville, N.J.

pp. 74–75. Courtesy of Pandion Art, Bernardsville, N.J.

pp. 76–77. Courtesy of Pandion Art, Bernardsville, N.J.

pp. 78–79. © 1984. Courtesy of the artist David A. Maass and Wild Wings, Inc., Lake City, MN.

p. 80. © 1986 Richard Casey. Courtesy of the artist and Mill Pond Press, Inc., Venice, FL 34292-3505.

p. 81. Courtesy of the artist.

pp. 82–83. © 1982. Courtesy of the artist Robert K. Abbett and Wild Wings, Inc., Lake City, MN.

pp. 84, 85. Courtesy of the artist.

p. 86. © 1984. Courtesy of the artist Robert K. Abbett and Wild Wings, Inc., Lake City, MN.

p. 87. © 1970. Courtesy of the artist Robert K. Abbett and Wild Wings, Inc., Lake City, MN.

pp. 88–89. © 1977 Robert Bateman. Courtesy of the artist and Mill Pond Press, Inc., Venice, FL 34292-3505.

p. 90. © 1979 Keith Shackleton. Courtesy of the artist and Mill Pond Press, Inc., Venice, FL 34292-3505.

p. 91. Courtesy of the artist.

p. 92. Courtesy of the artist.

pp. 92–93. © 1977 Keith Shackleton. Courtesy of the artist and Mill Pond Press, Inc., Venice, FL 34292-3505.

pp. 94, 95. Courtesy of the artist.

pp. 96–97. © 1984 Richard Casey. Courtesy of the artist and Mill Pond Press, Inc., Venice, FL 34292-3505.

p. 97 (bottom). Courtesy of the artist.

pp. 98, 99. Courtesy of the artist.

pp. 100, 101. Courtesy of the artist.

p. 102. Courtesy of the artist.

pp. 102–103. © 1984 Keith Shackleton. Courtesy of the artist and Mill Pond Press, Inc., Venice, FL 34292-3505.

pp. 104–105. Courtesy of the artist.

pp. 106, 107. Courtesy of the artist.

pp. 108, 109. Courtesy of the artist.

p. 111. Courtesy of the artist.

pp. 112–113. Courtesy of the artist.

pp. 114, 115. Courtesy of Pandion Art, Bernardsville, N.J.

pp. 116–117. © 1985 Richard Casey. Courtesy of the artist and Mill Pond Press, Inc., Venice, FL 34292-3505.

pp. 118, 119. Courtesy of the artist.

pp. 120, 121. Courtesy of the artist.

pp. 122–123. Courtesy of Pandion Art, Bernardsville, N.J.

pp. 124–125. © 1985 Richard Casey. Courtesy of the artist and Mill Pond Press Inc., Venice, FL 34292-3505.

pp. 124–125 (bottom). Courtesy of the artist.

p. 126. © 1986 Richard Casey. Courtesy of the artist and Mill Pond Press, Inc., Venice, FL 34292-3505.

p. 127. Courtesy of the artist.

pp. 128–129. © 1985 Robert Bateman. Courtesy of the artist and Mill Pond Press, Inc., Venice, FL 34292-3505.

p. 131. © 1987. Courtesy of the artist Robert K. Abbett and Wild Wings, Inc., Lake City, MN.

p. 132. © 1986 Robert Bateman. Courtesy of the artist and Mill Pond Press, Inc., Venice, FL 34292-3505.

p. 133. Courtesy of the artist.

p. 134. © 1988 Richard Casey. Courtesy of the artist and Mill Pond Press, Inc., Venice, FL 34292-3505.

p. 135. Courtesy of Pandion Art, Bernardsville, N.J.

p. 136. Courtesy of the artist.

p. 137. © 1986. Courtesy of the artist David A. Maass and Wild Wings Inc., Lake City, MN.

p. 138. Courtesy of the artist.

p. 139. Courtesy of the artist.

p. 140. Courtesy of the Russell A. Fink Gallery, Lorton, VA.

p. 141. Courtesy of the artist.

p. 142. © 1986 Keith Shackleton. Courtesy of the artist and Mill Pond Press, Inc., Venice, FL 34292-3505.

Index